Sines.
Tangents.
Cycles.

drawn by: Michael Schaefer
of
Ink on Paper Arts in Oregon

Other work as well as prints
available for purchase via:
FB: Iopa Inor
Imgur: IoPA inOR

copyright: 2016 by Amazon/CreateSpace publishing

All rights reserved.
No part of this book may be reproduced or copied without written permission of the author.

ISBN-13:
978-1537287935

ISBN-10:
1537287931

For G.A. & Gary Don,
two fine gentlemen.

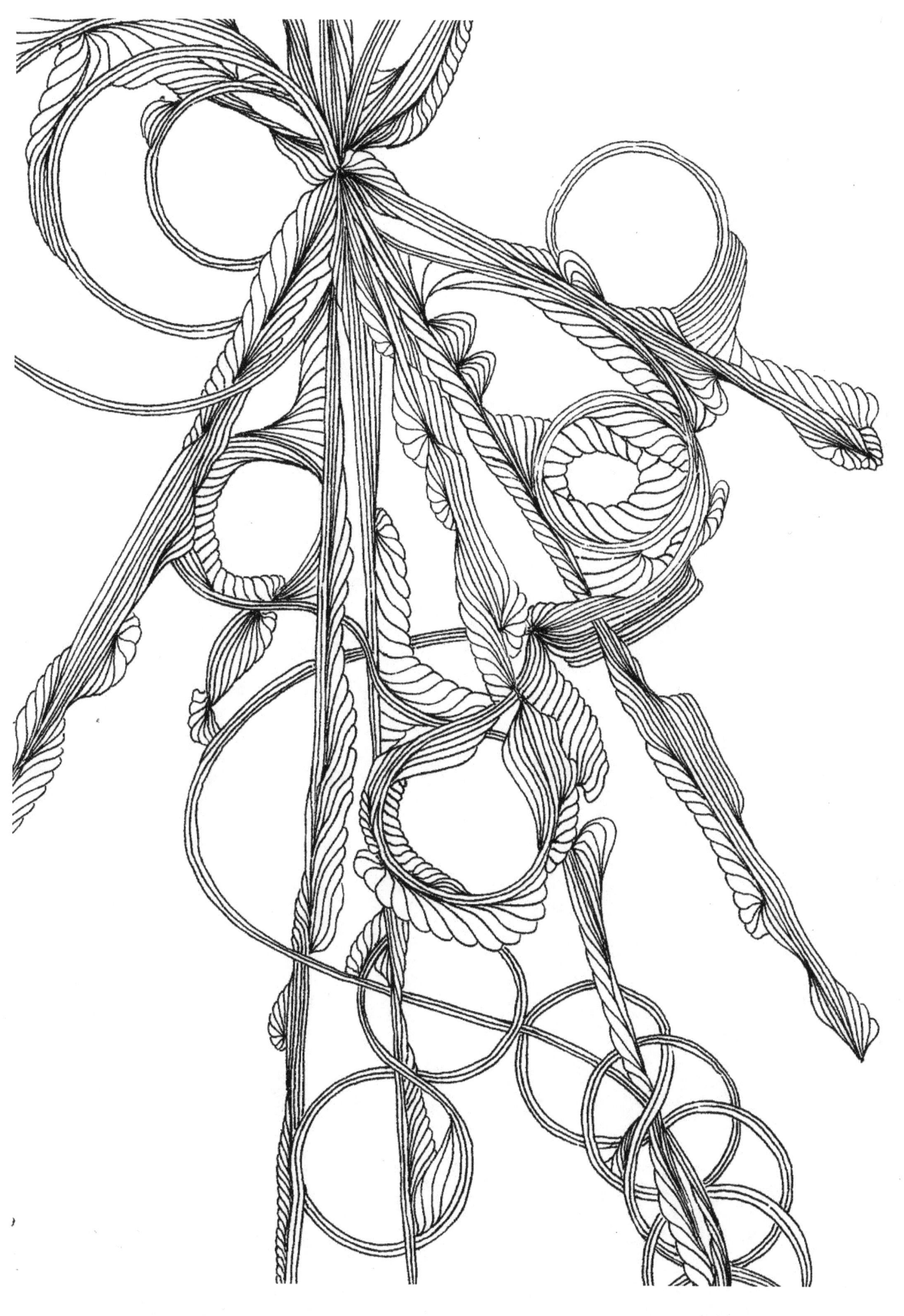

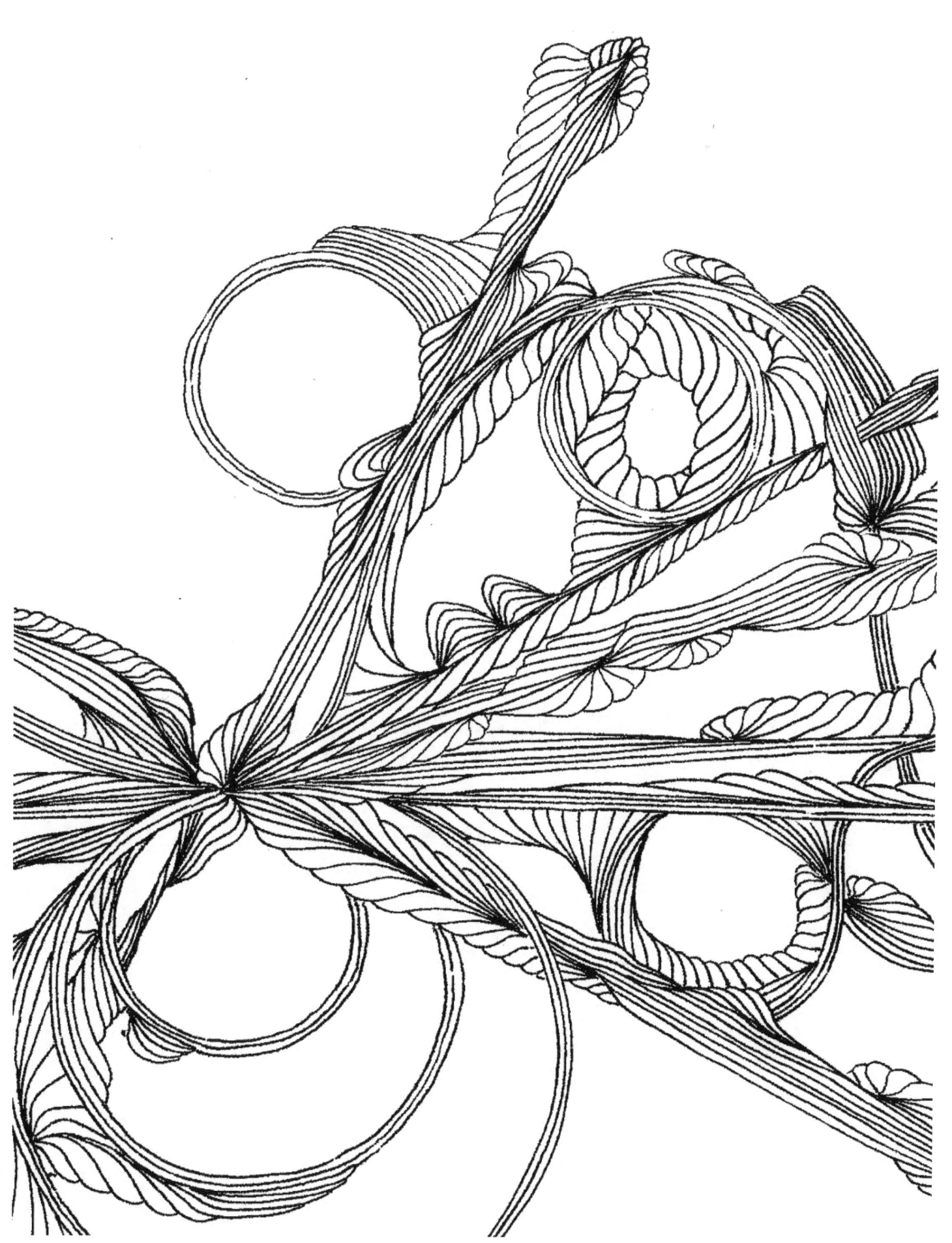

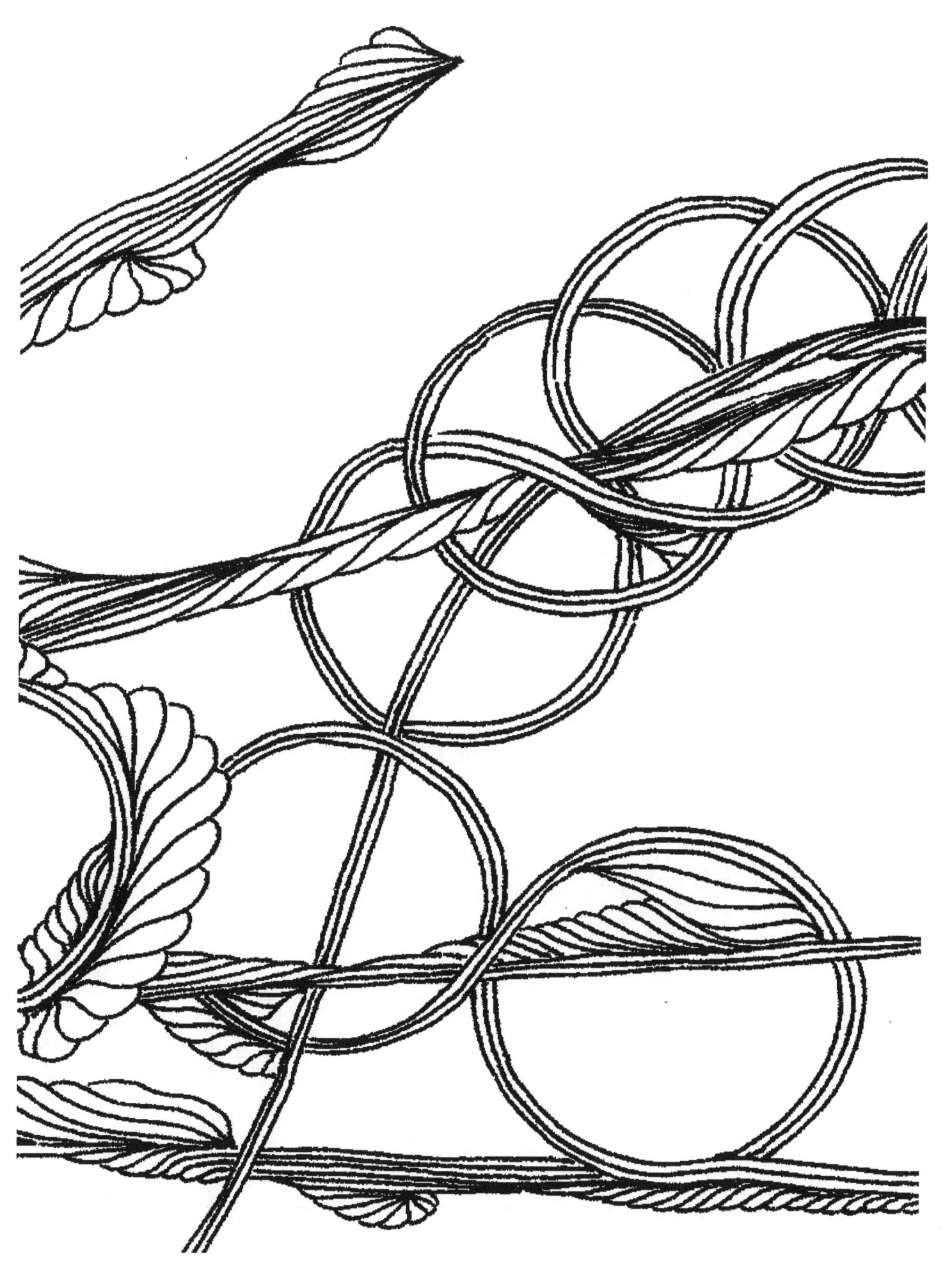

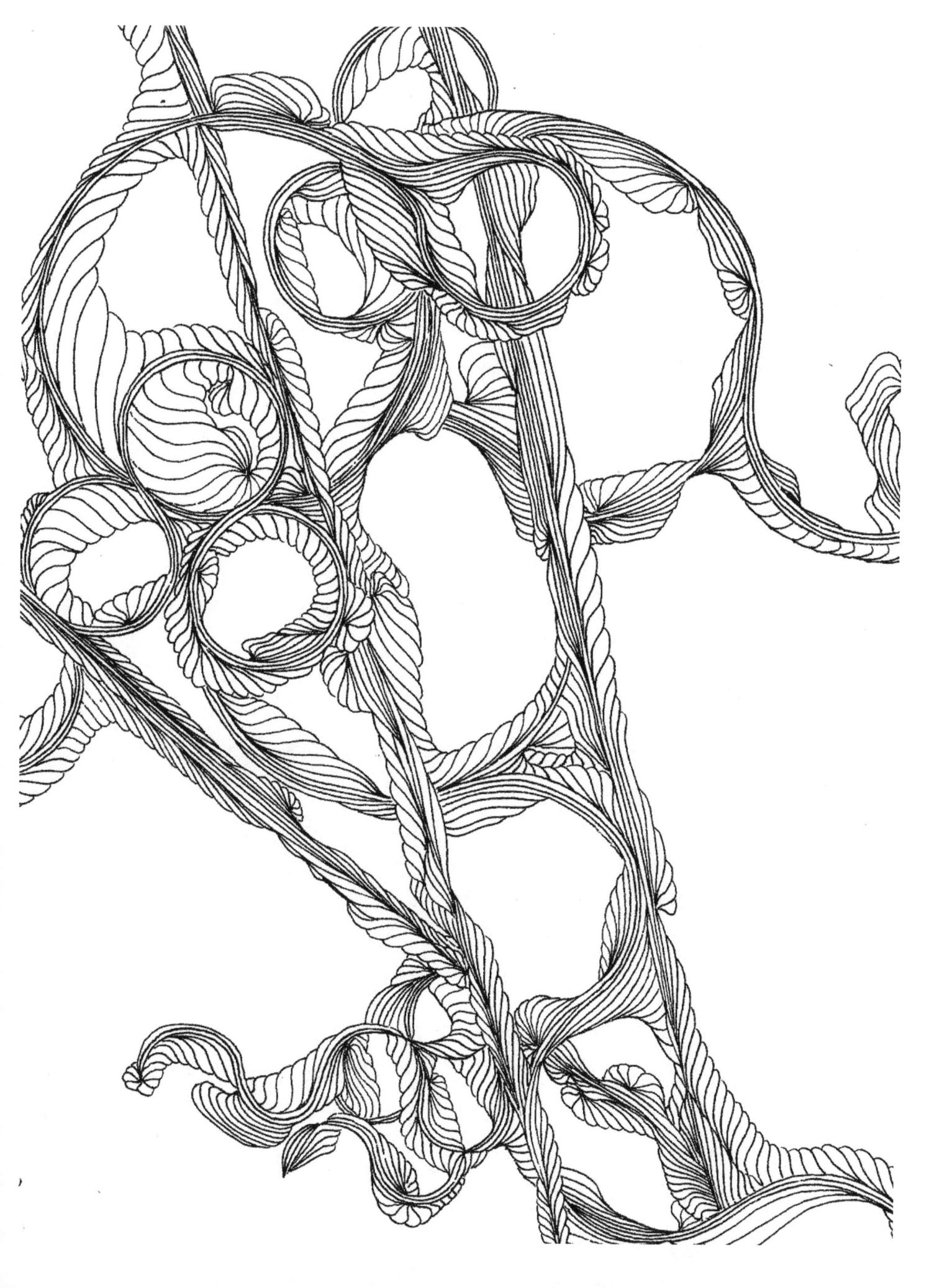

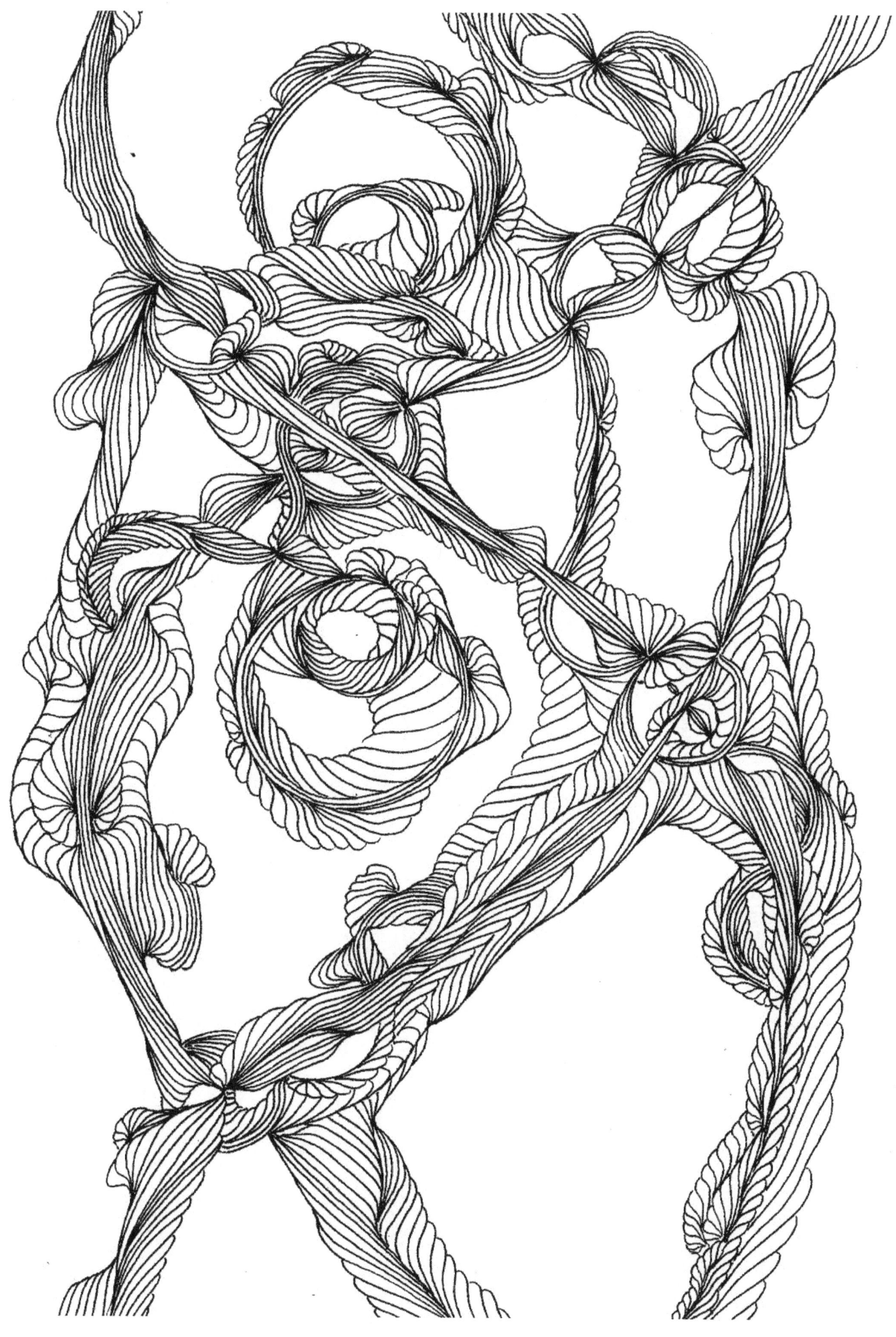

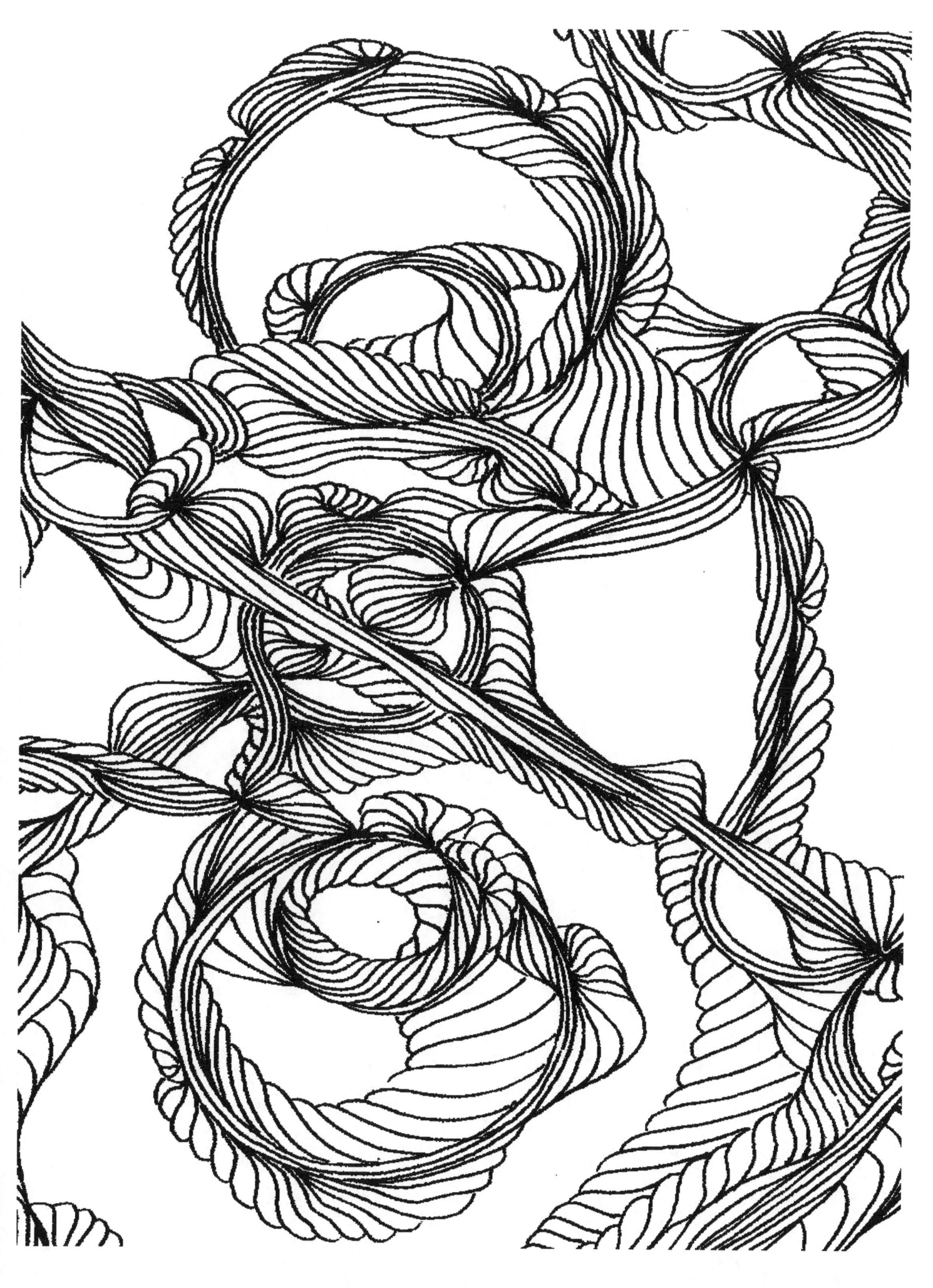

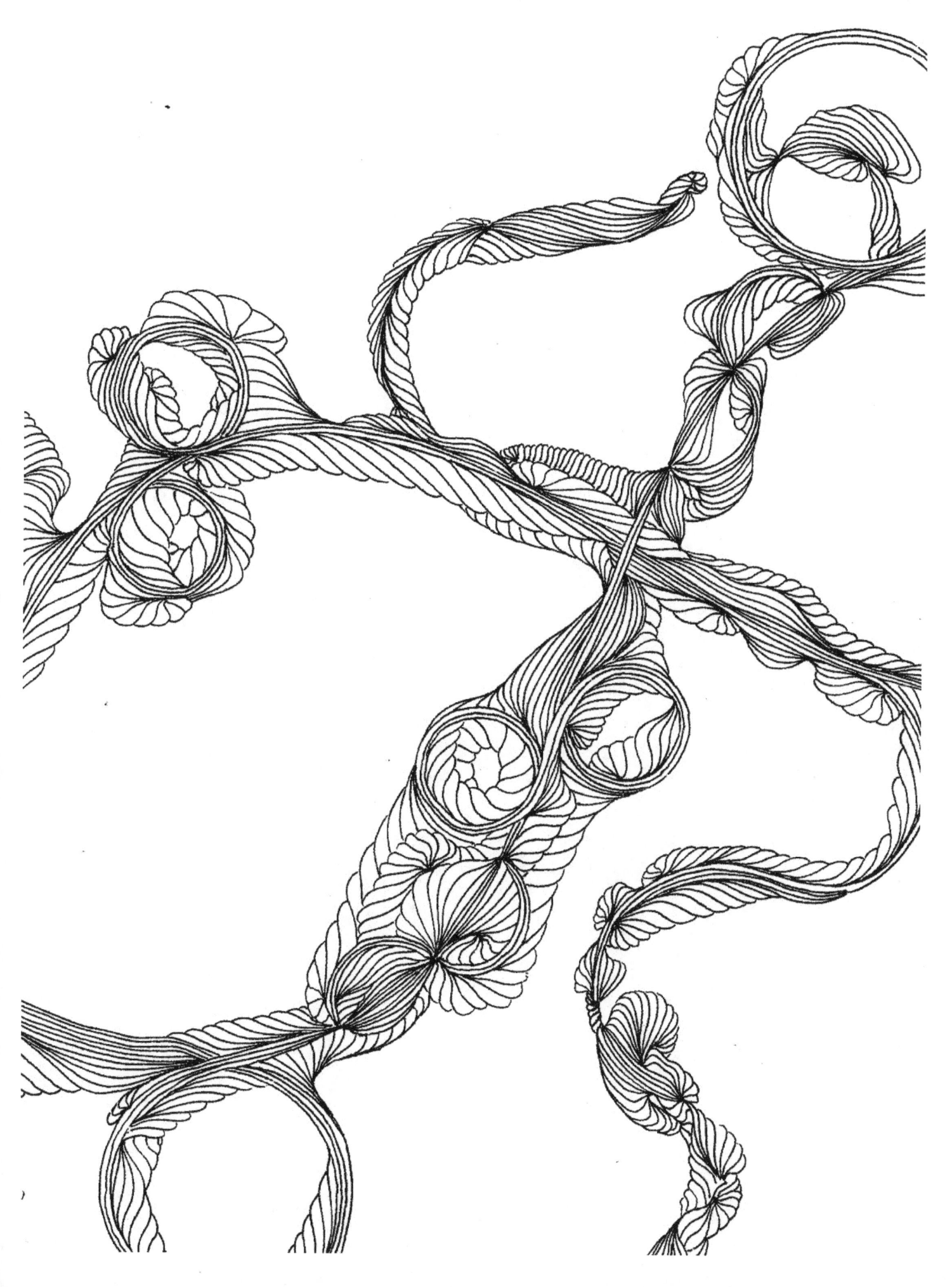

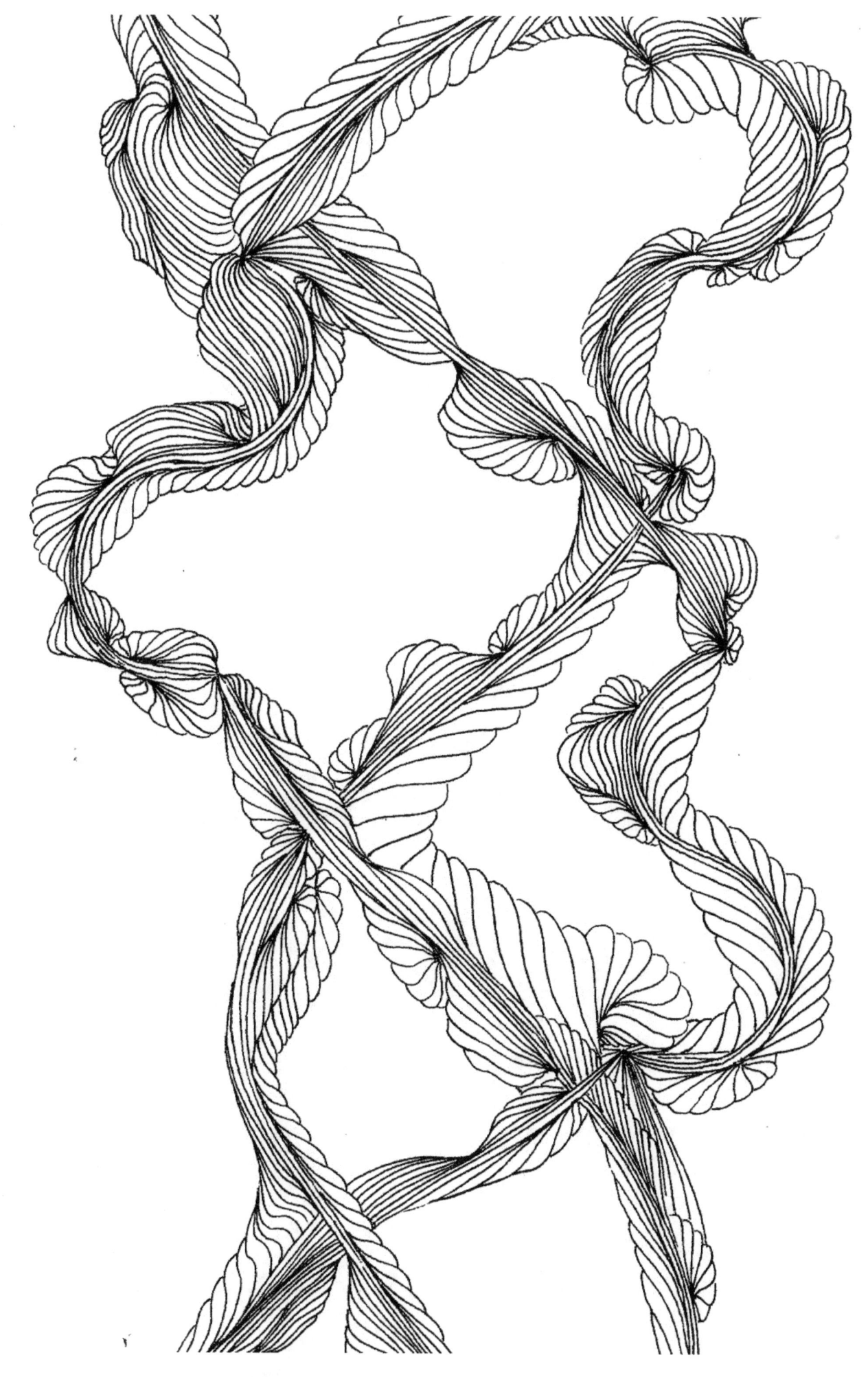

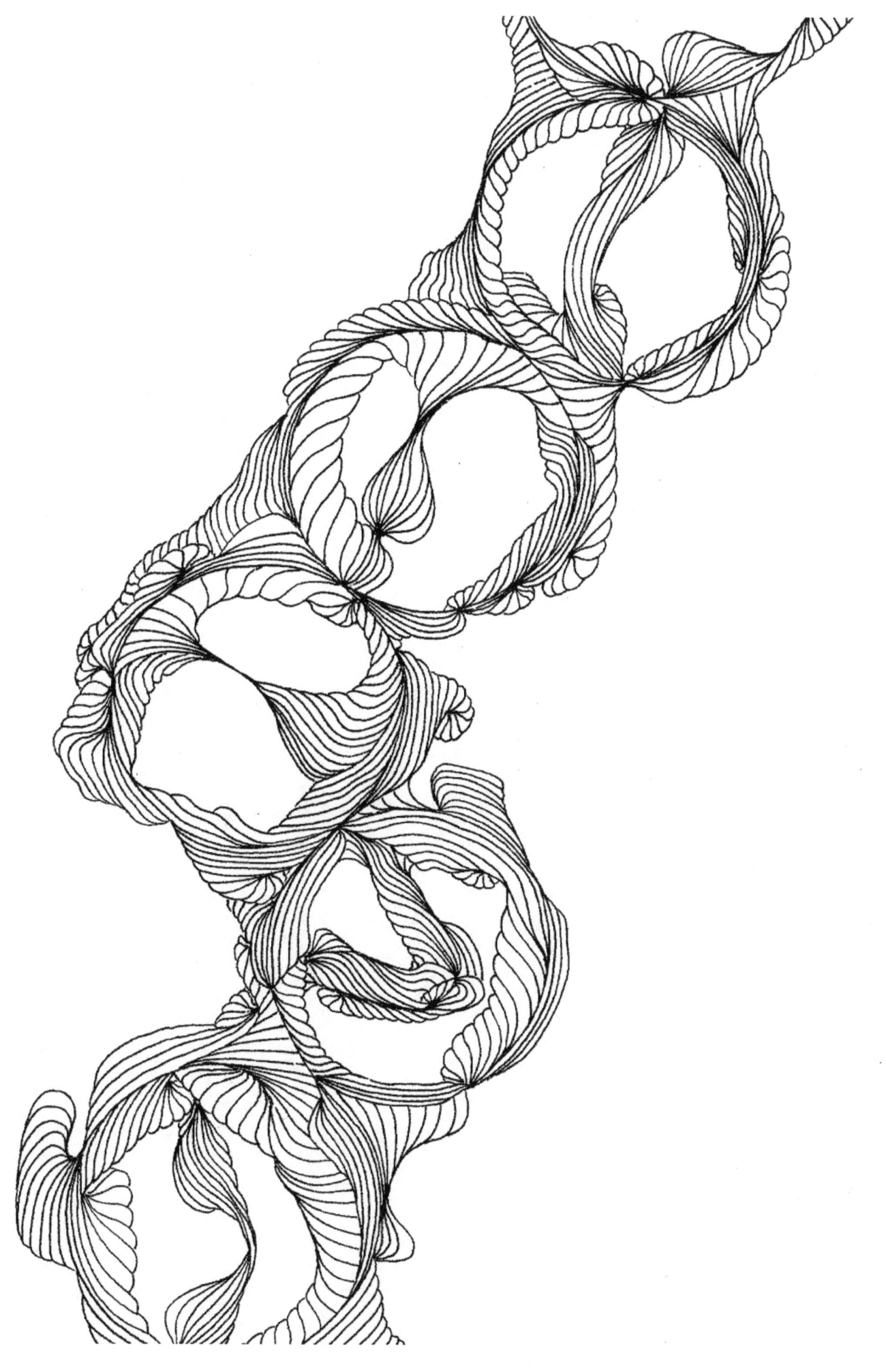

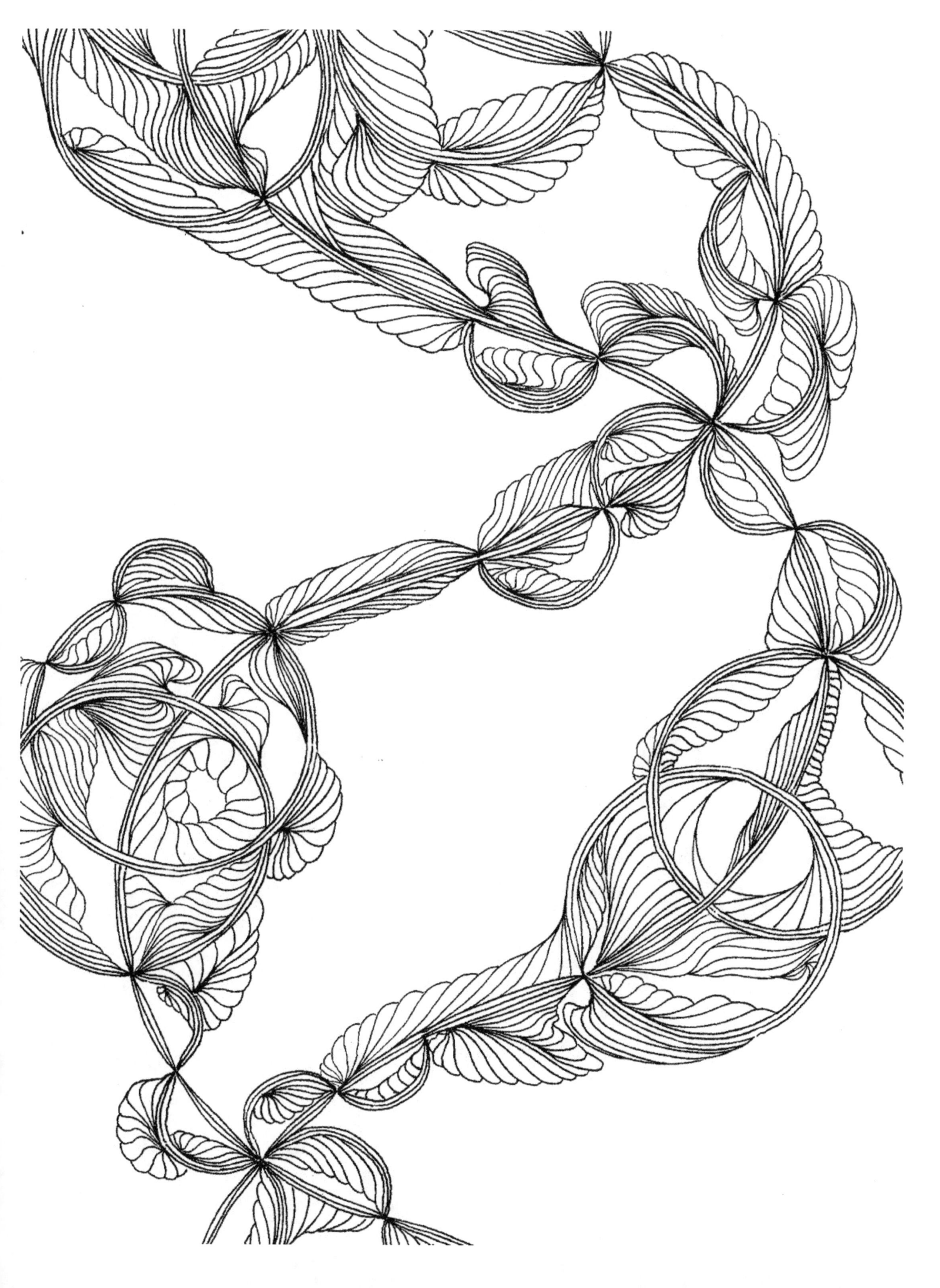

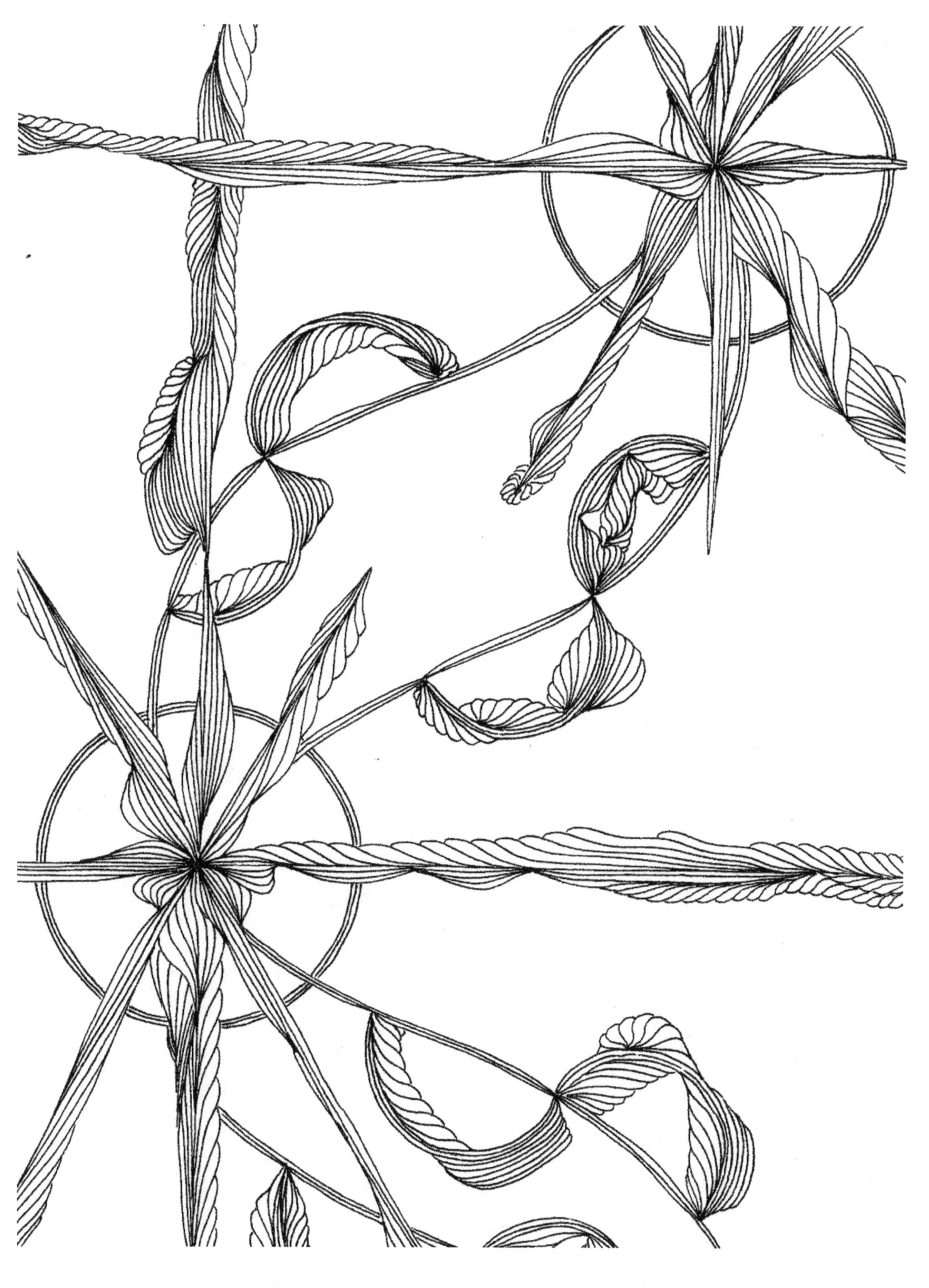

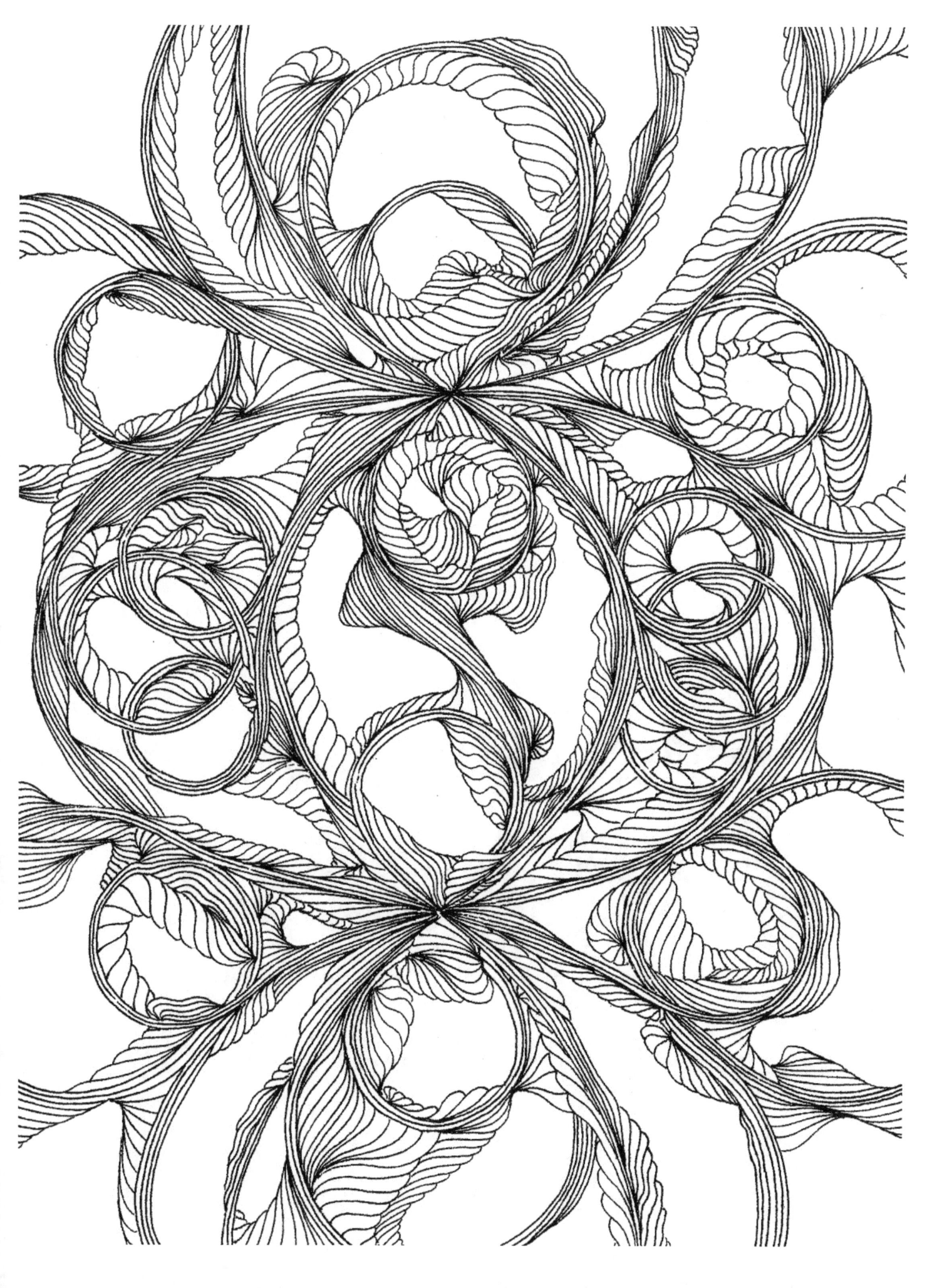

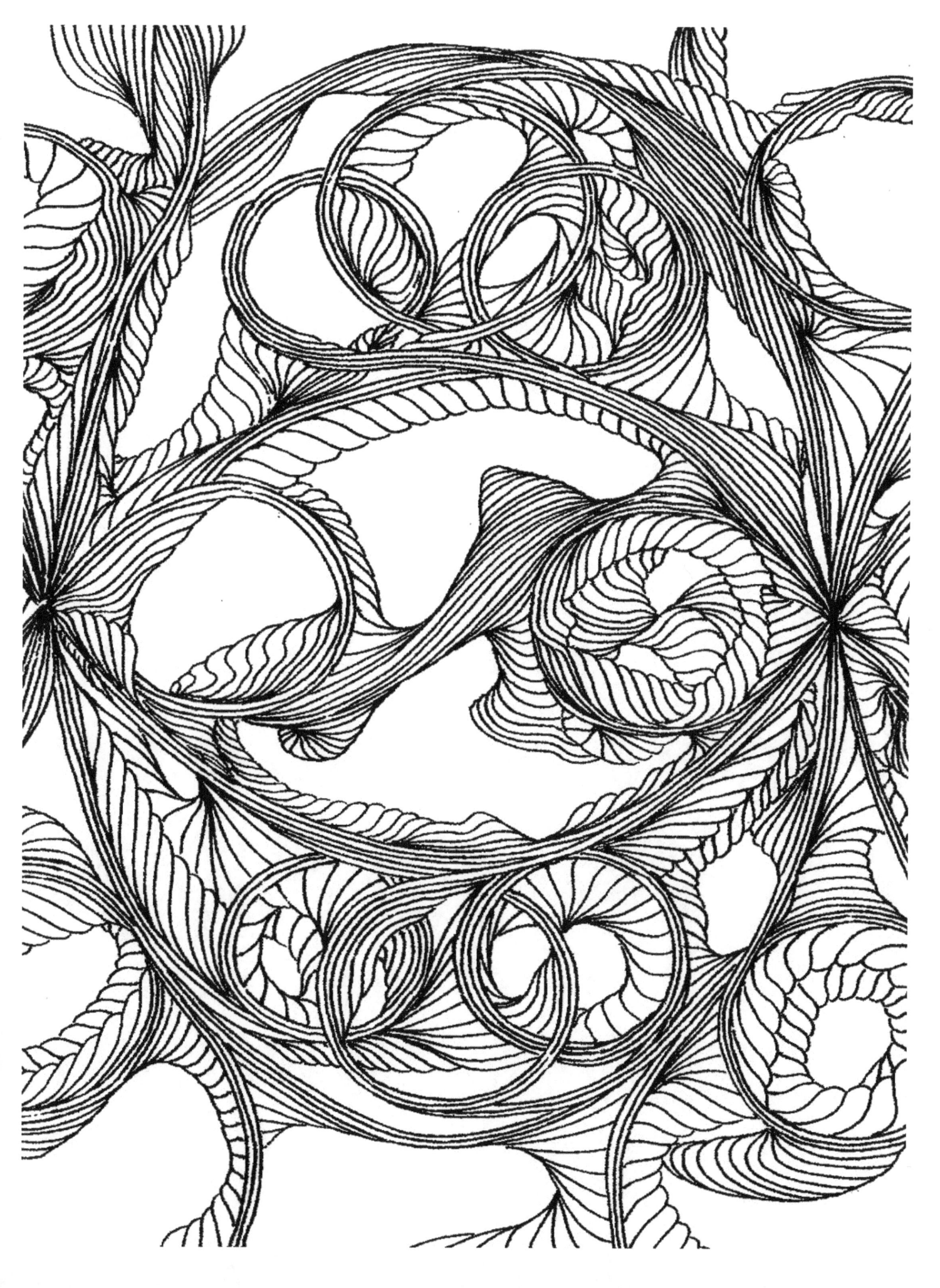

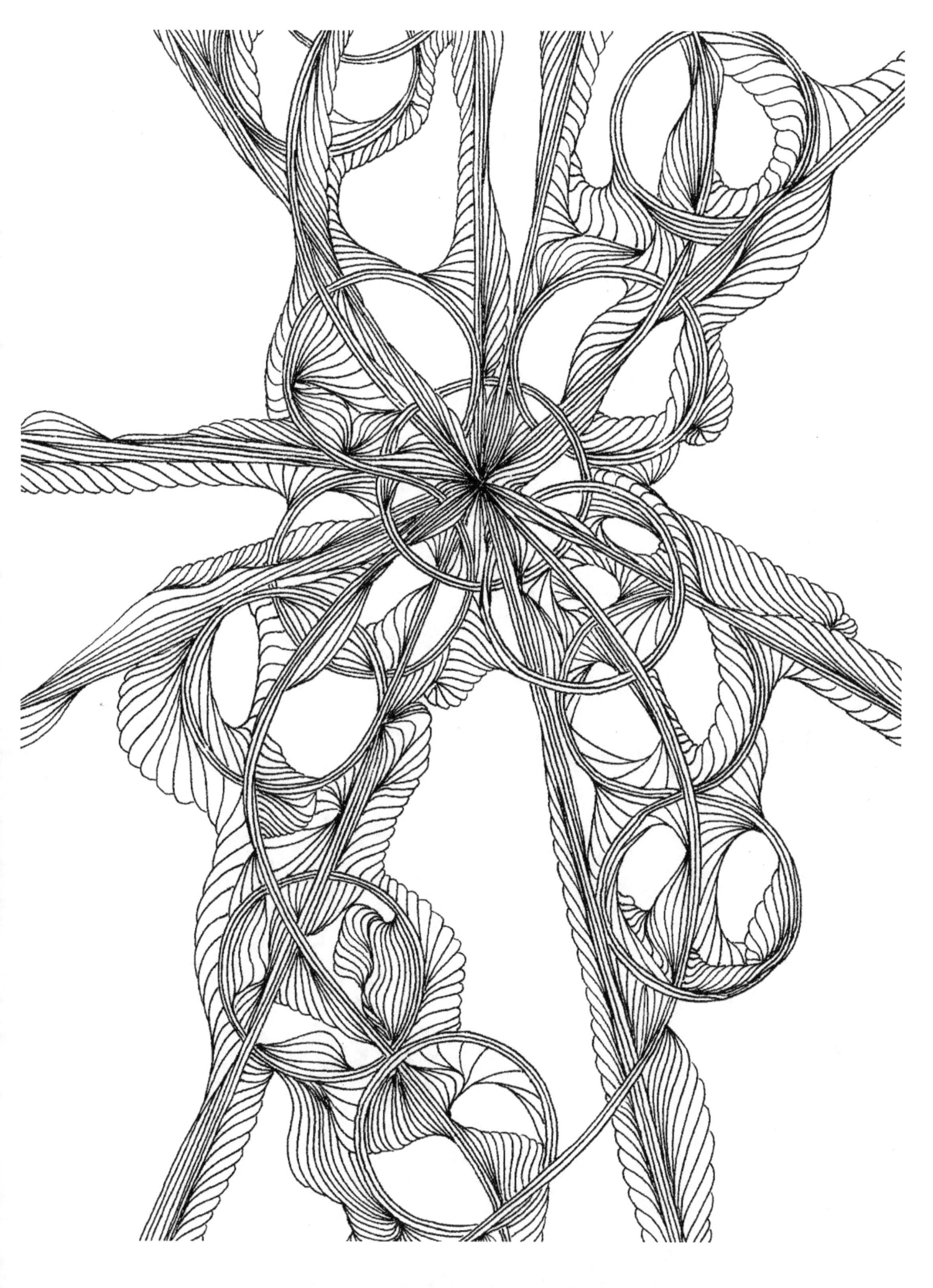

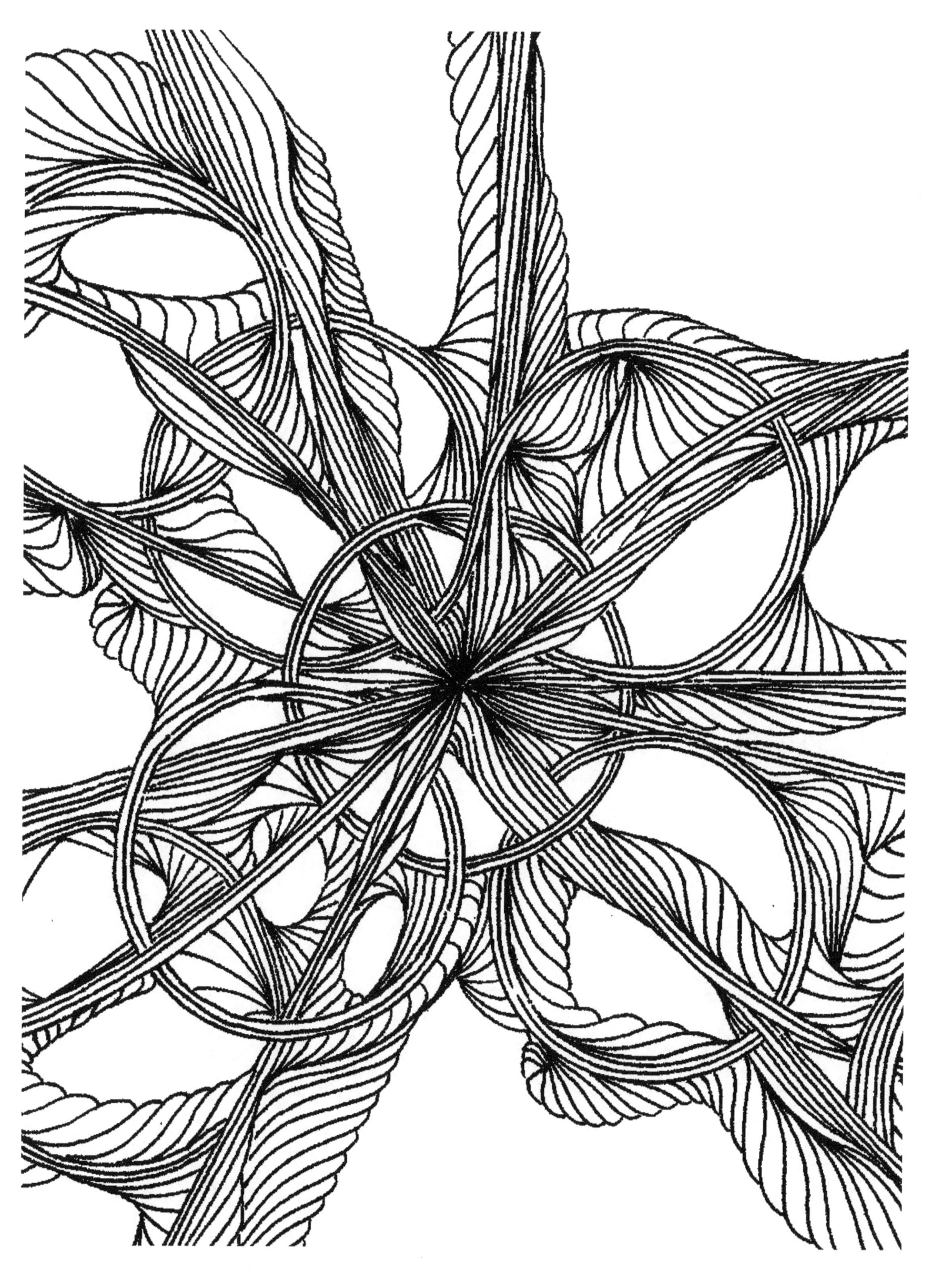

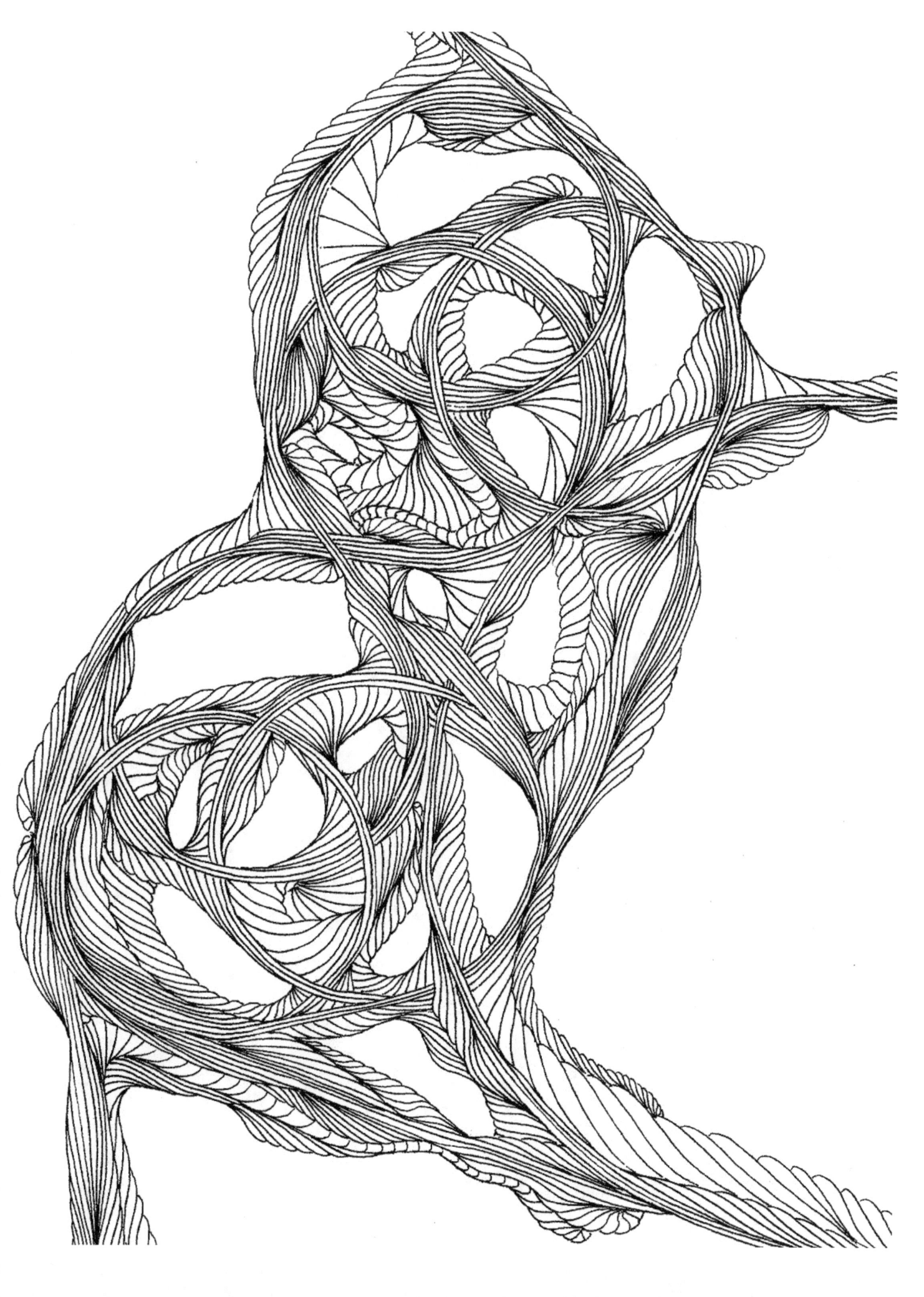

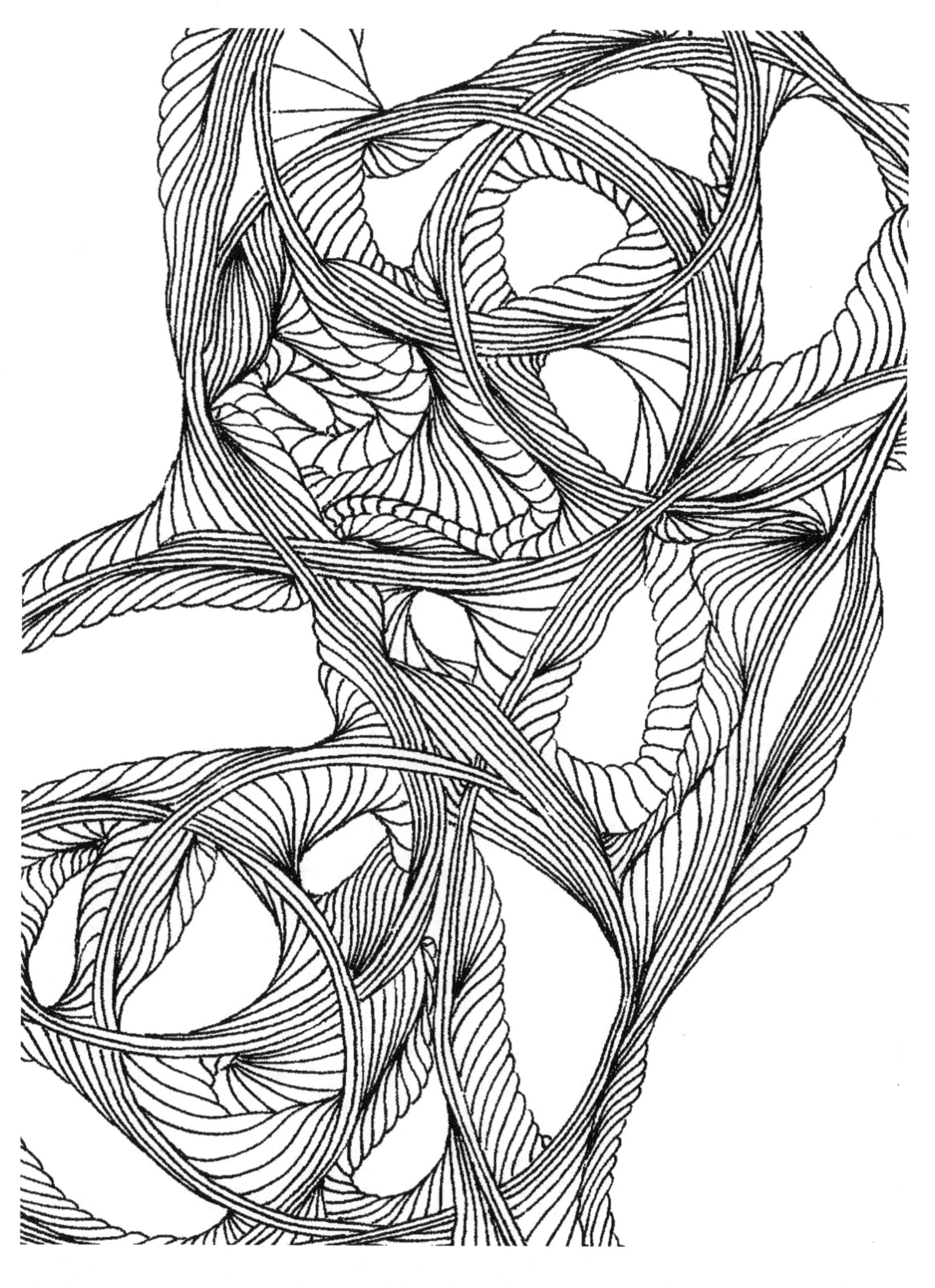

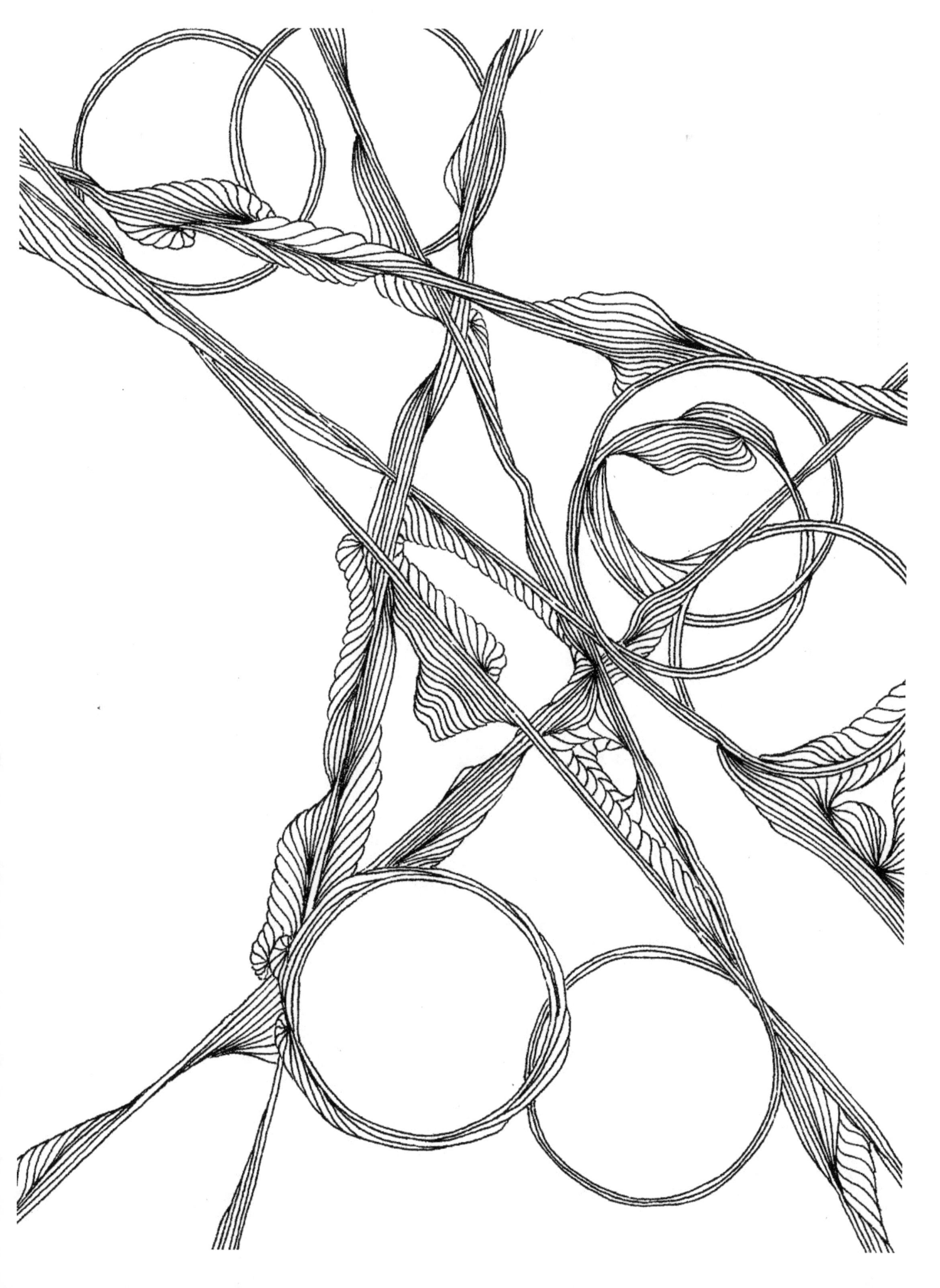

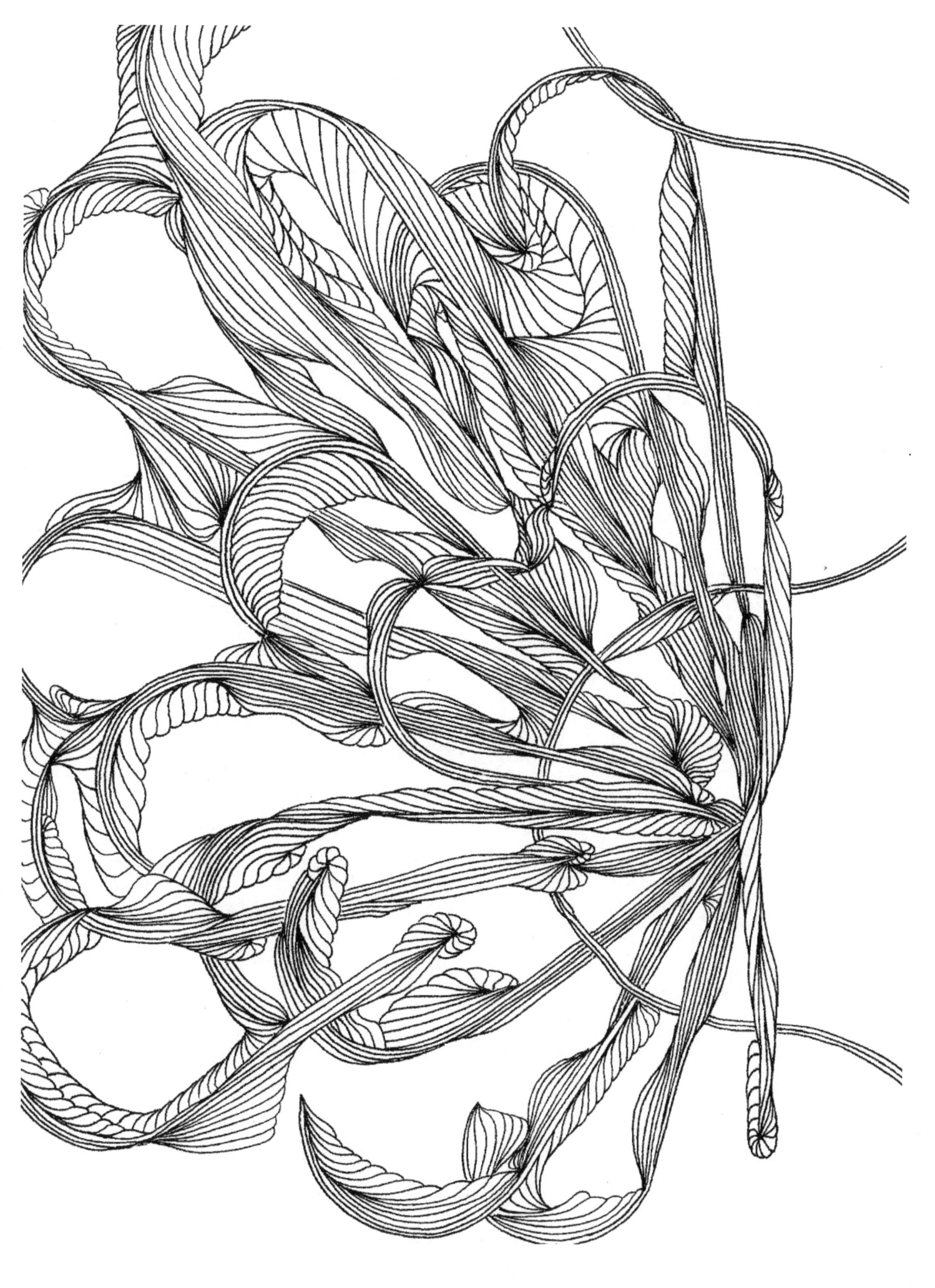

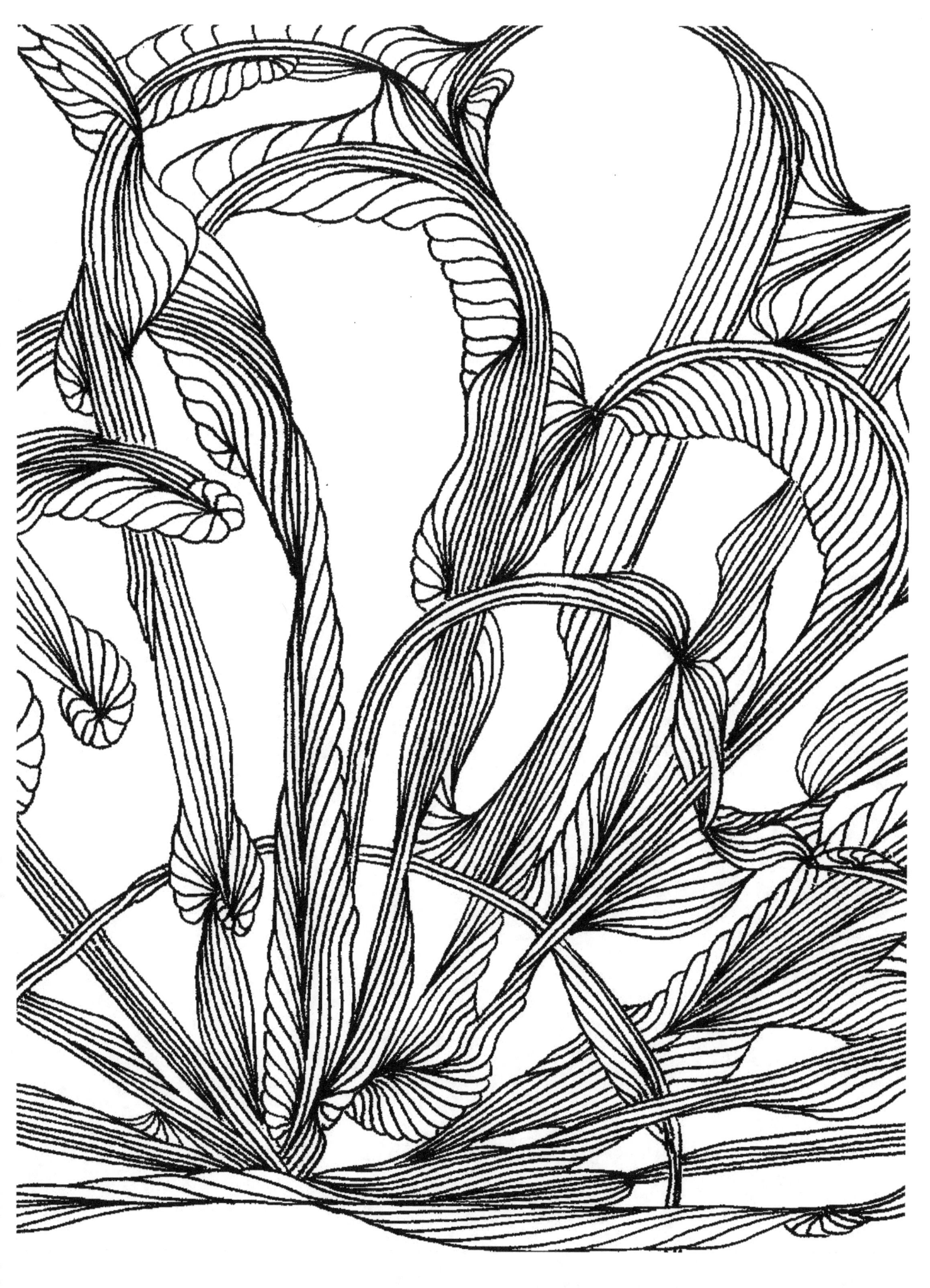

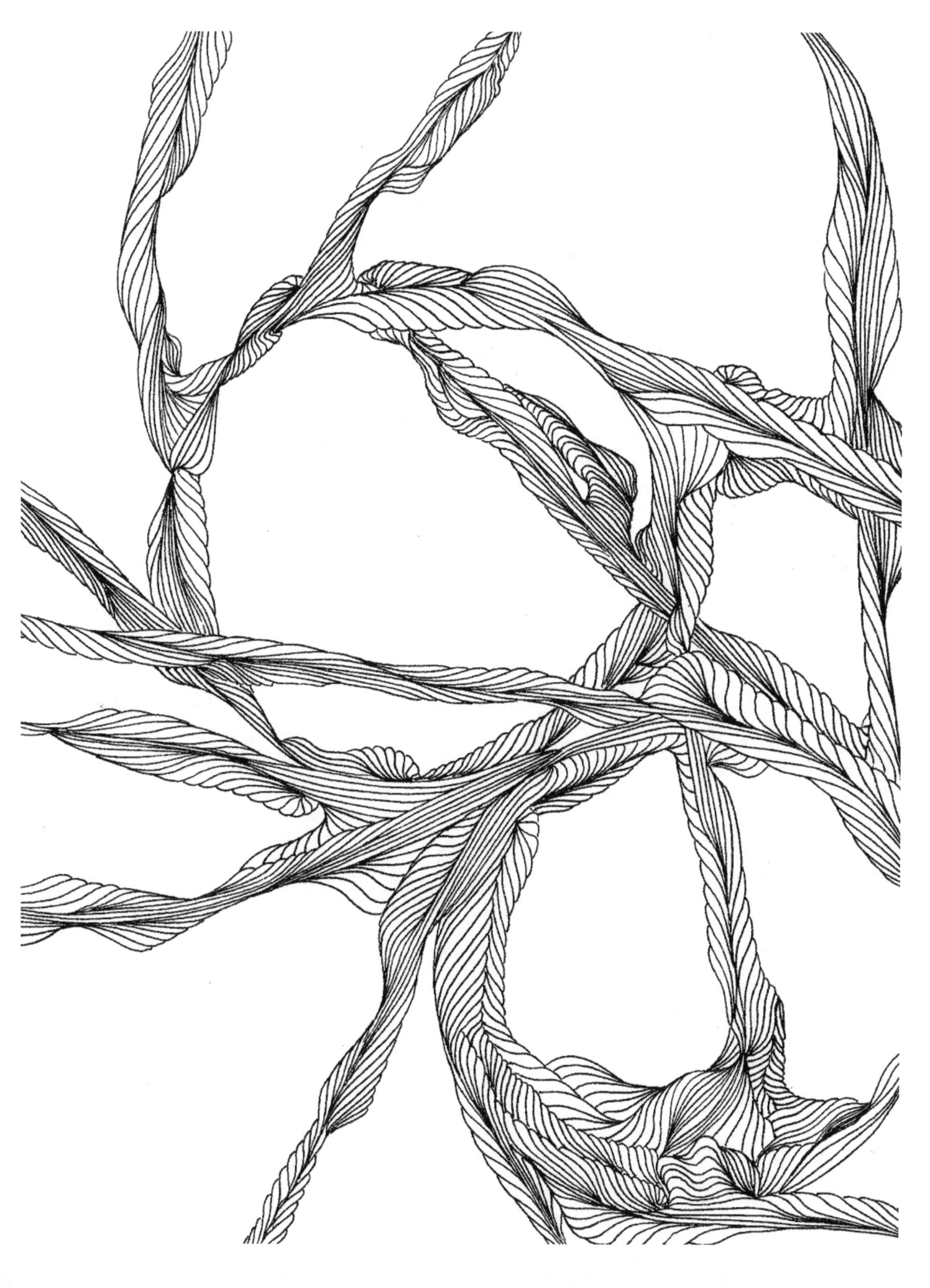

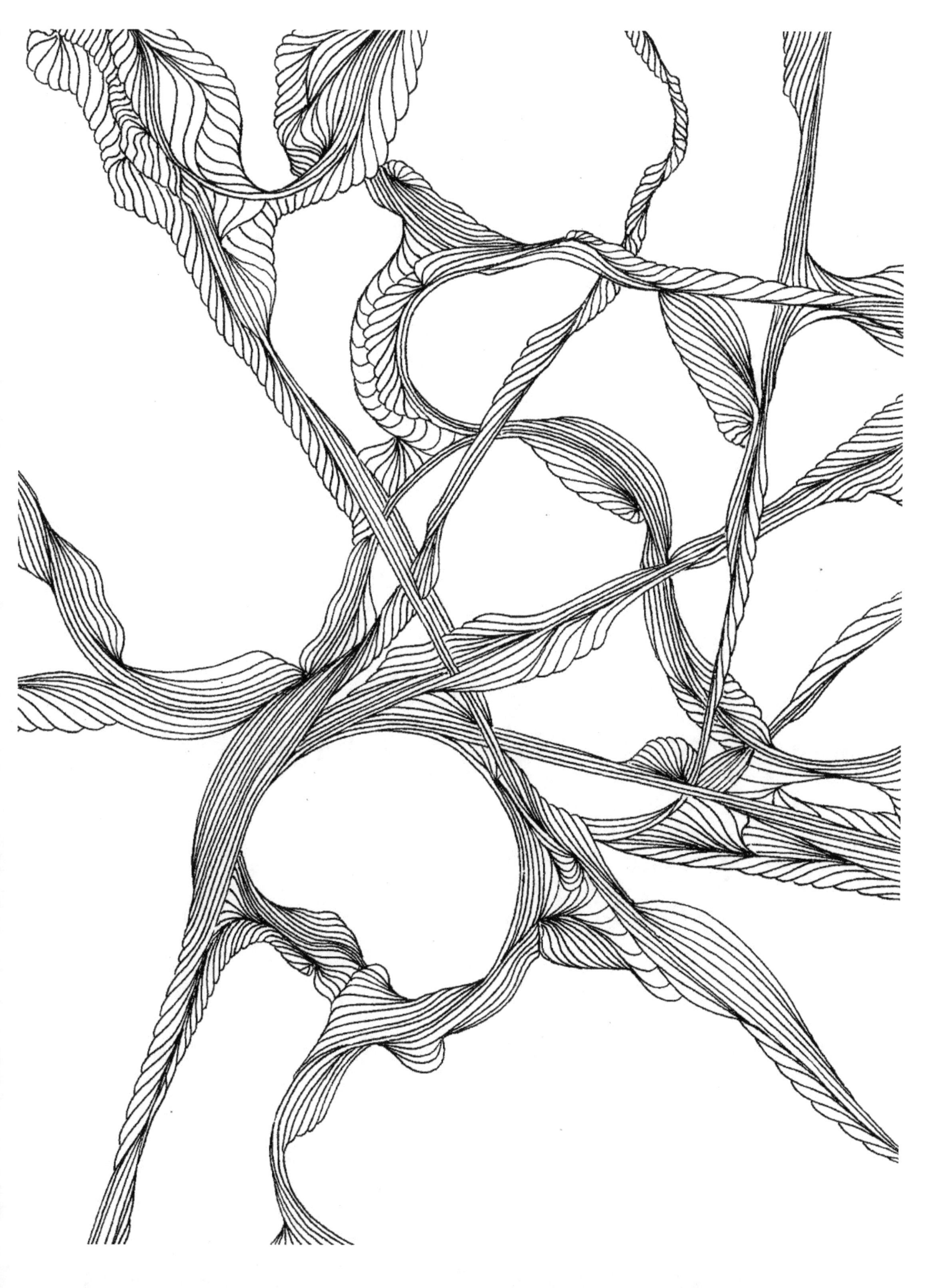

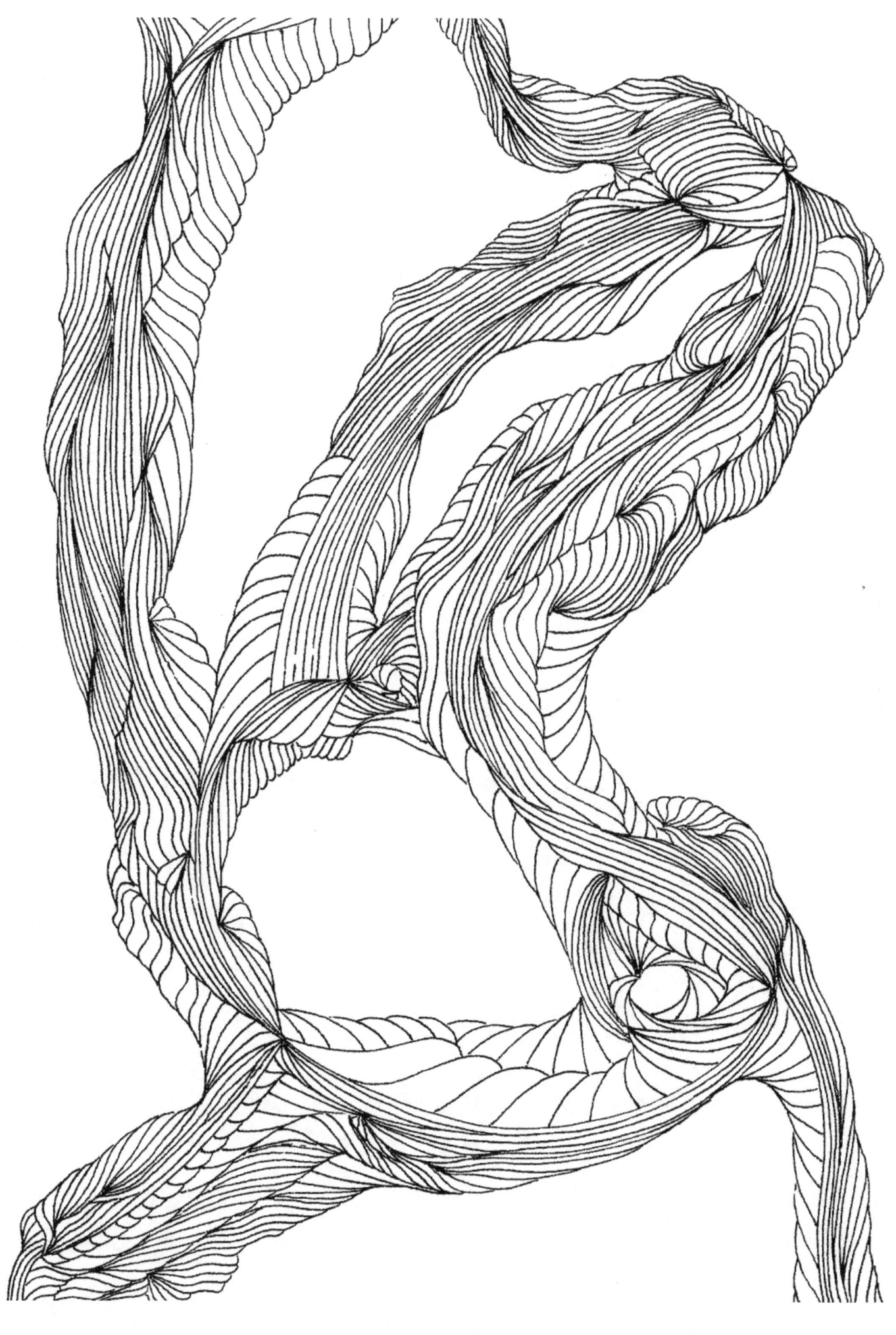

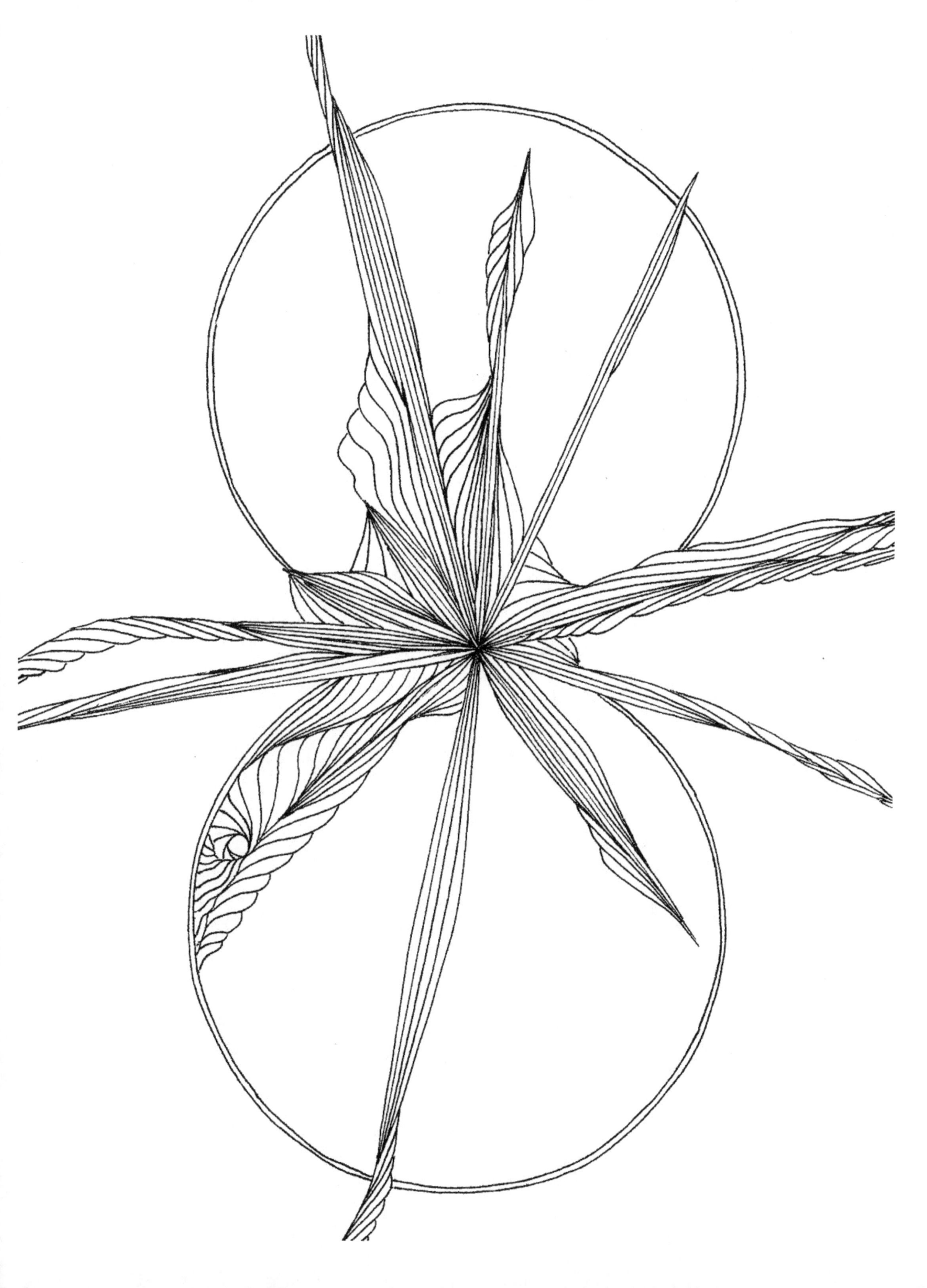

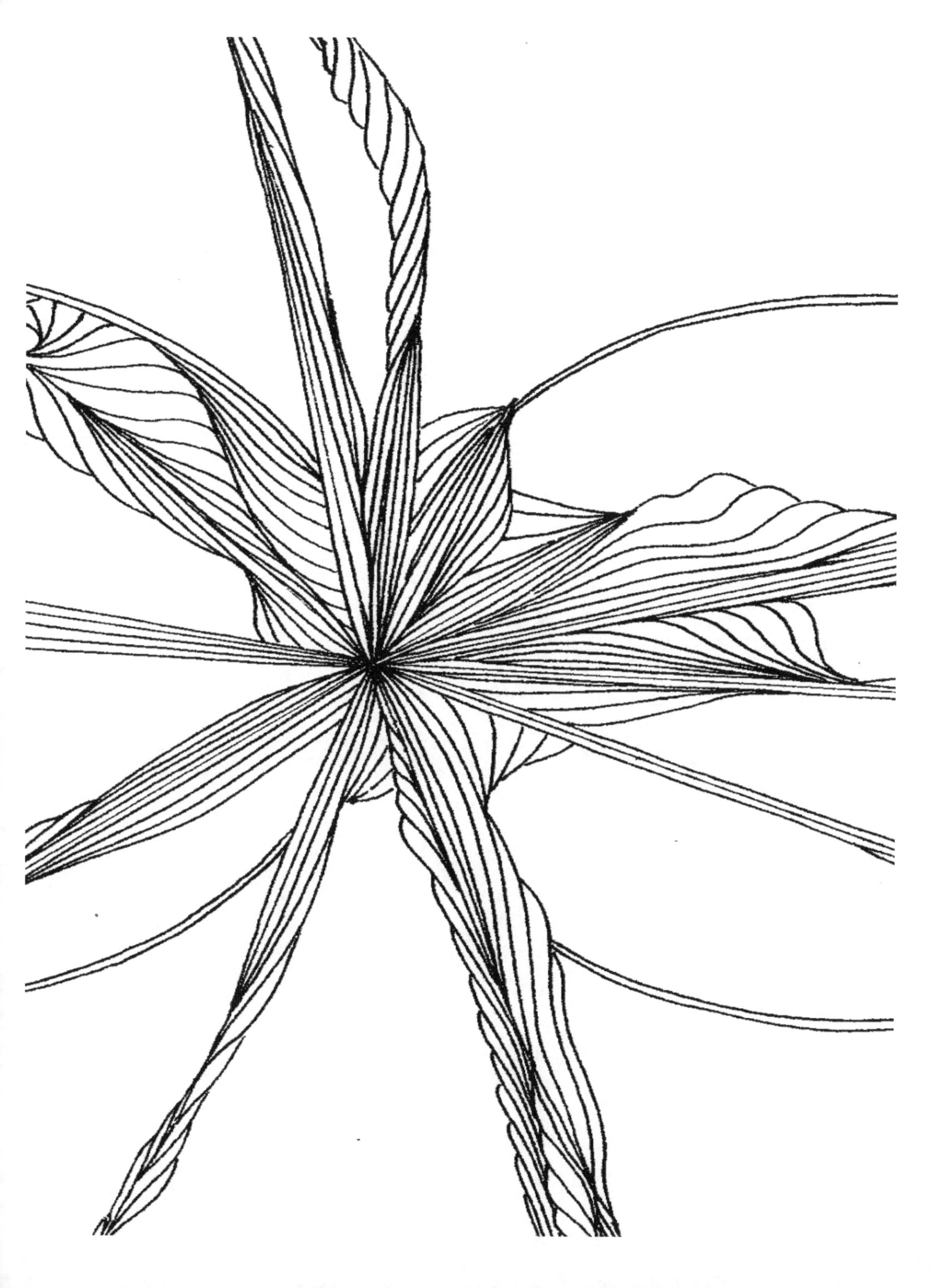

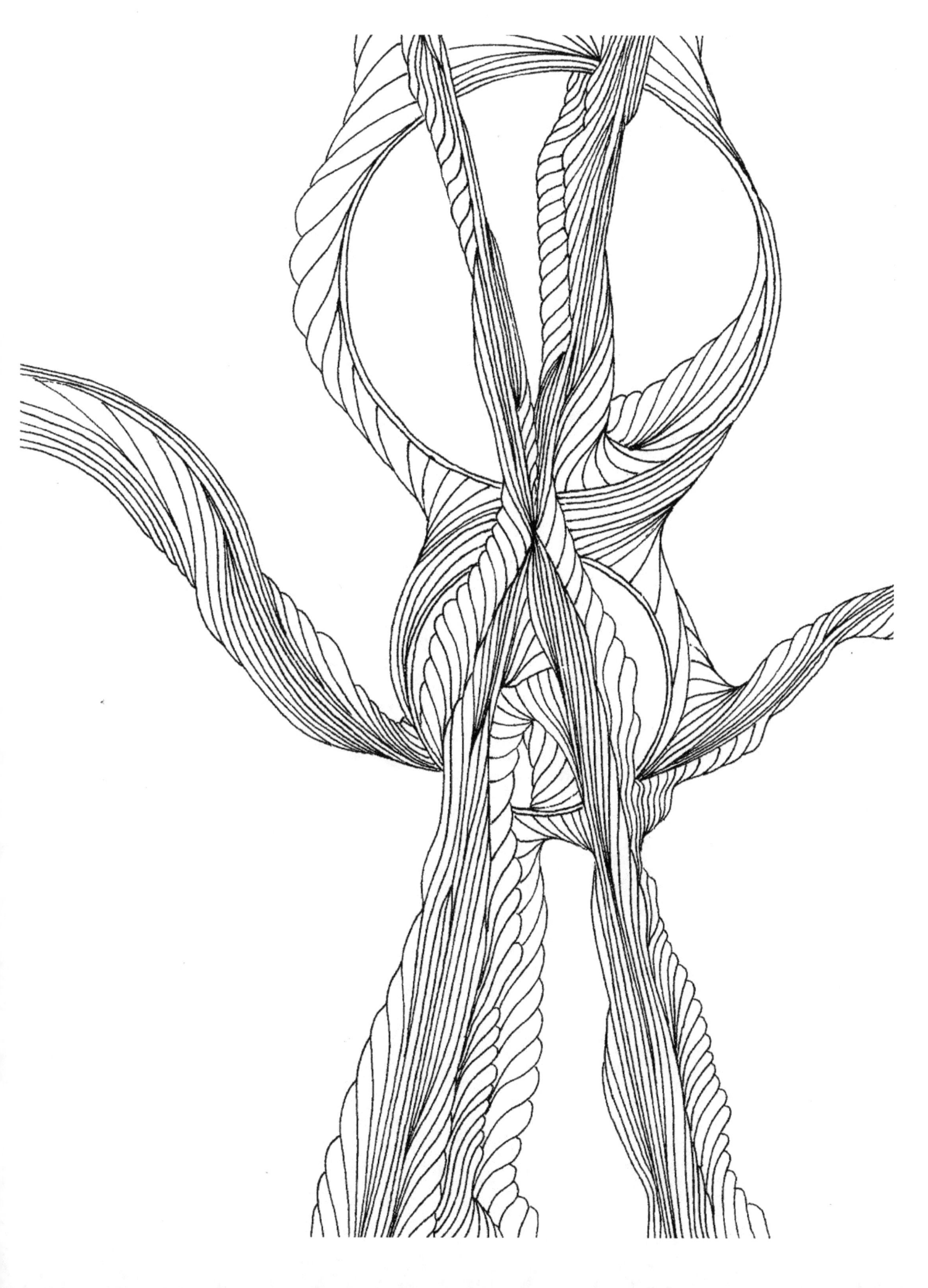

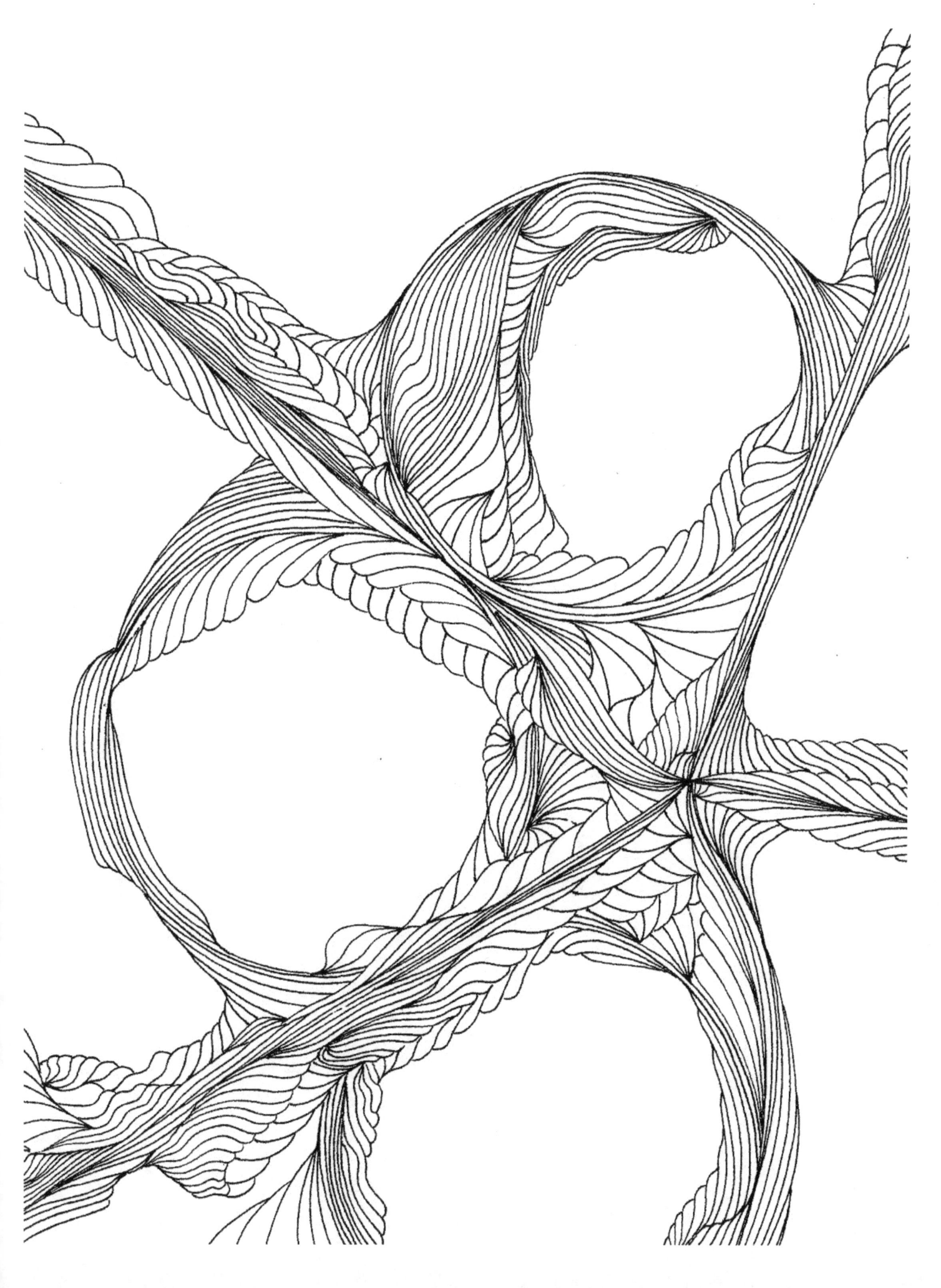

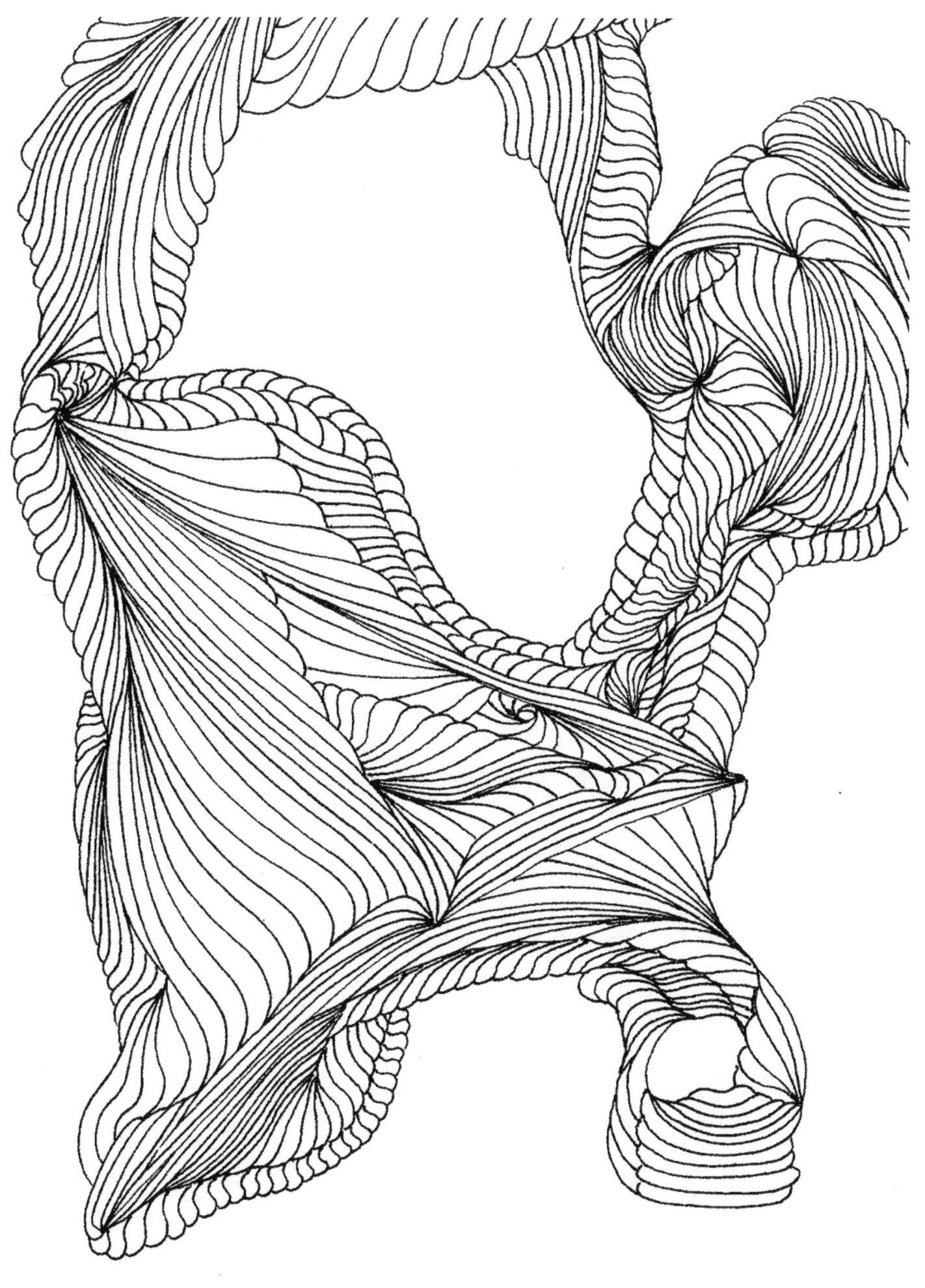

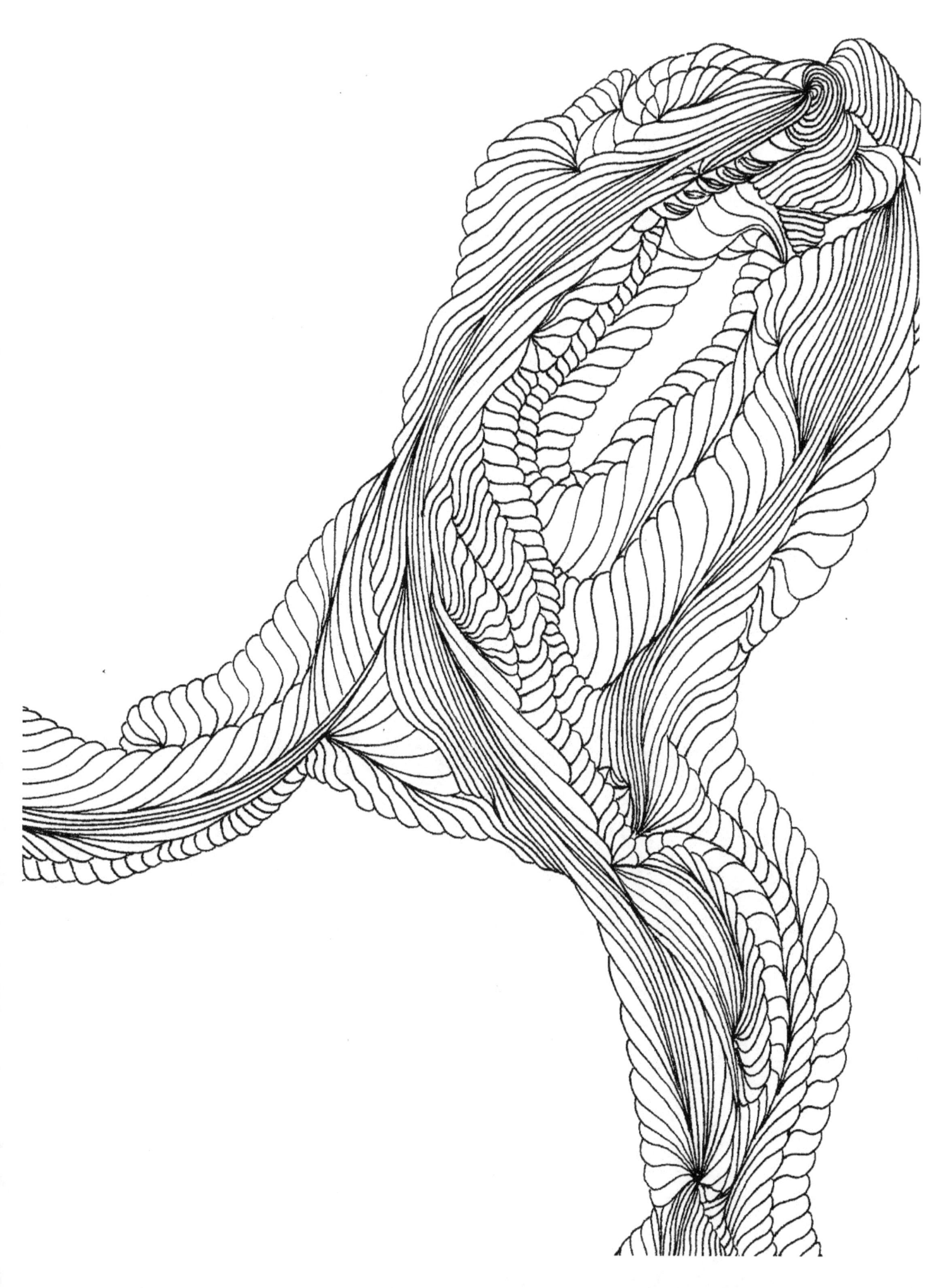

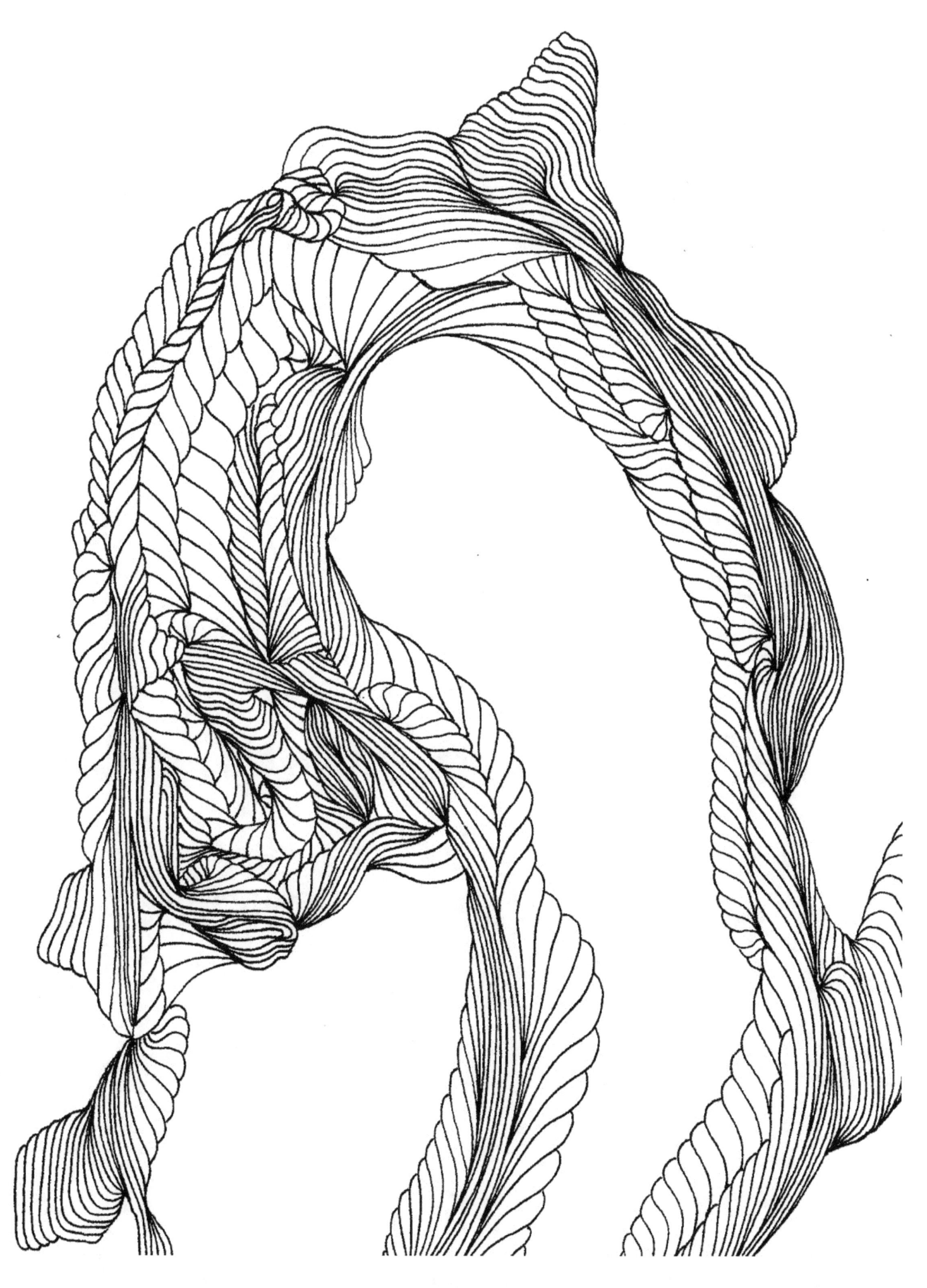

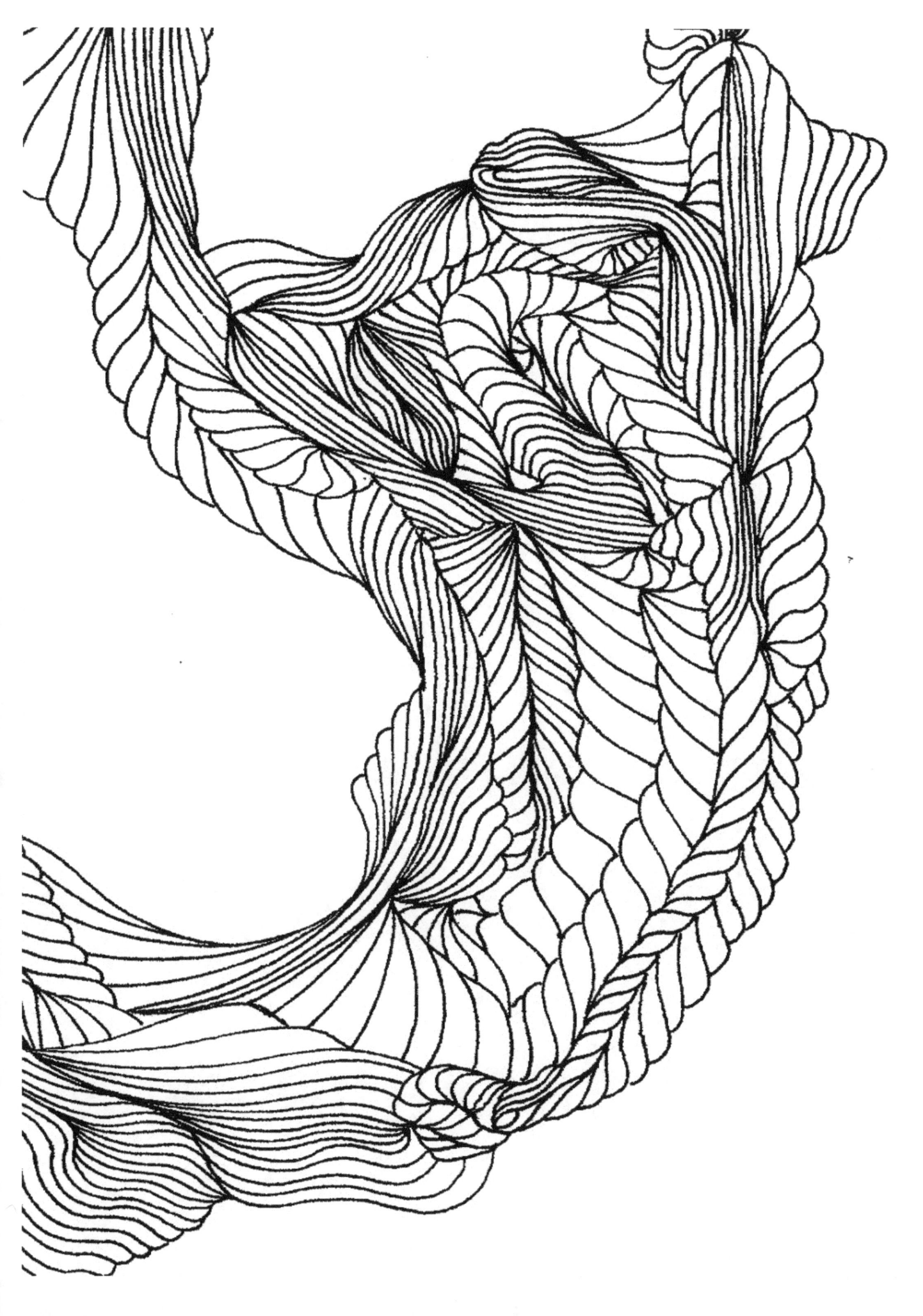

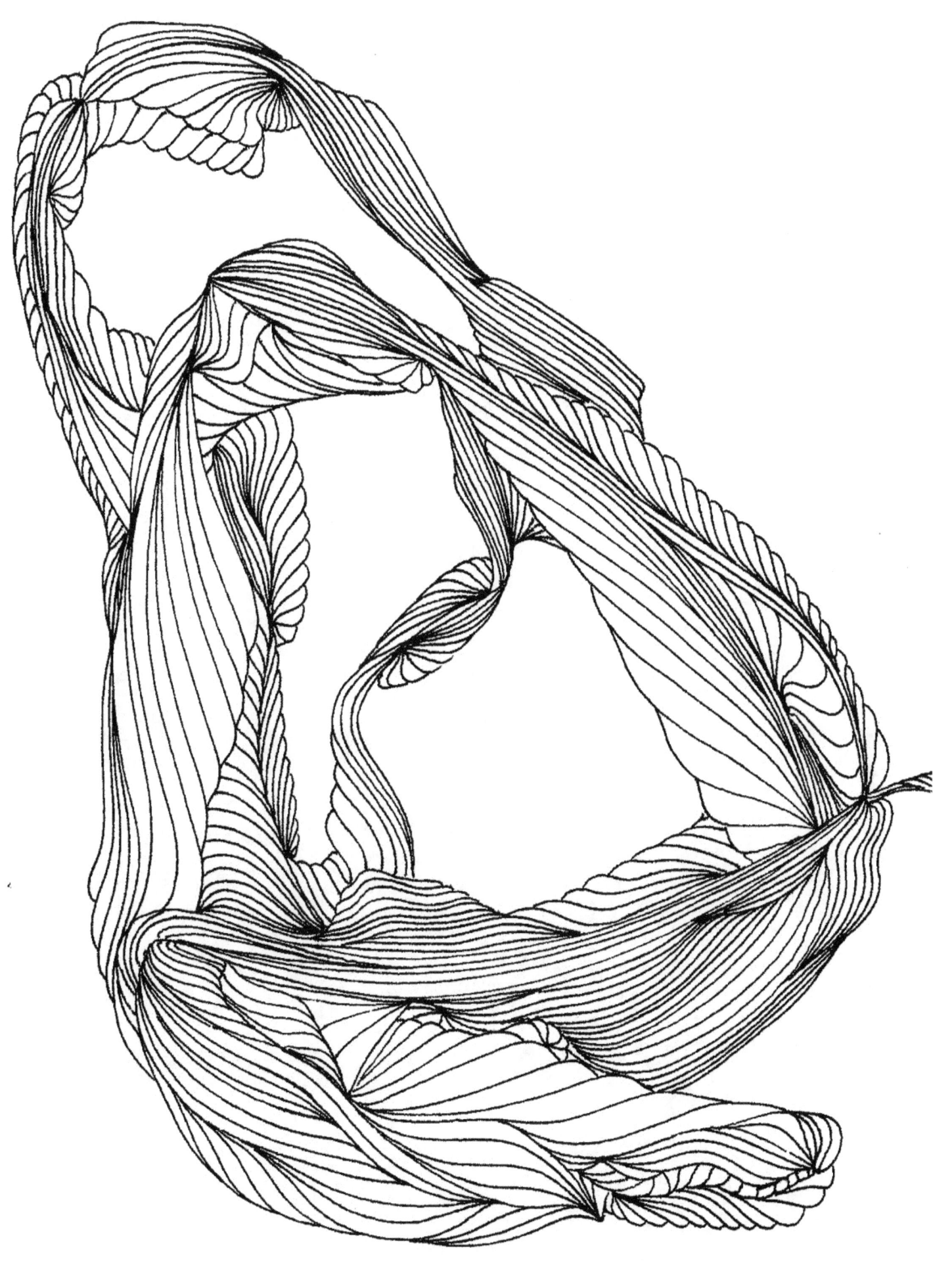

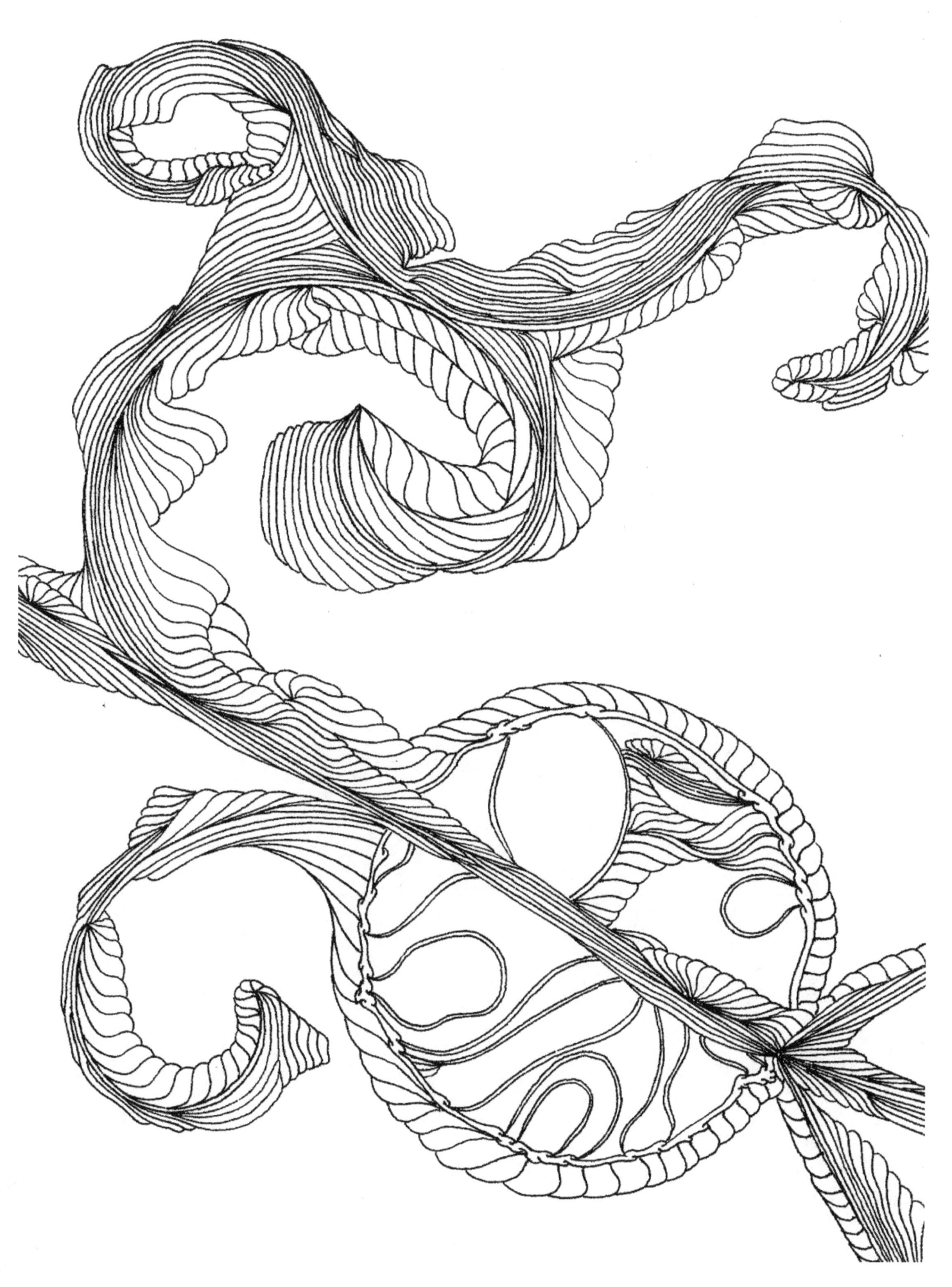

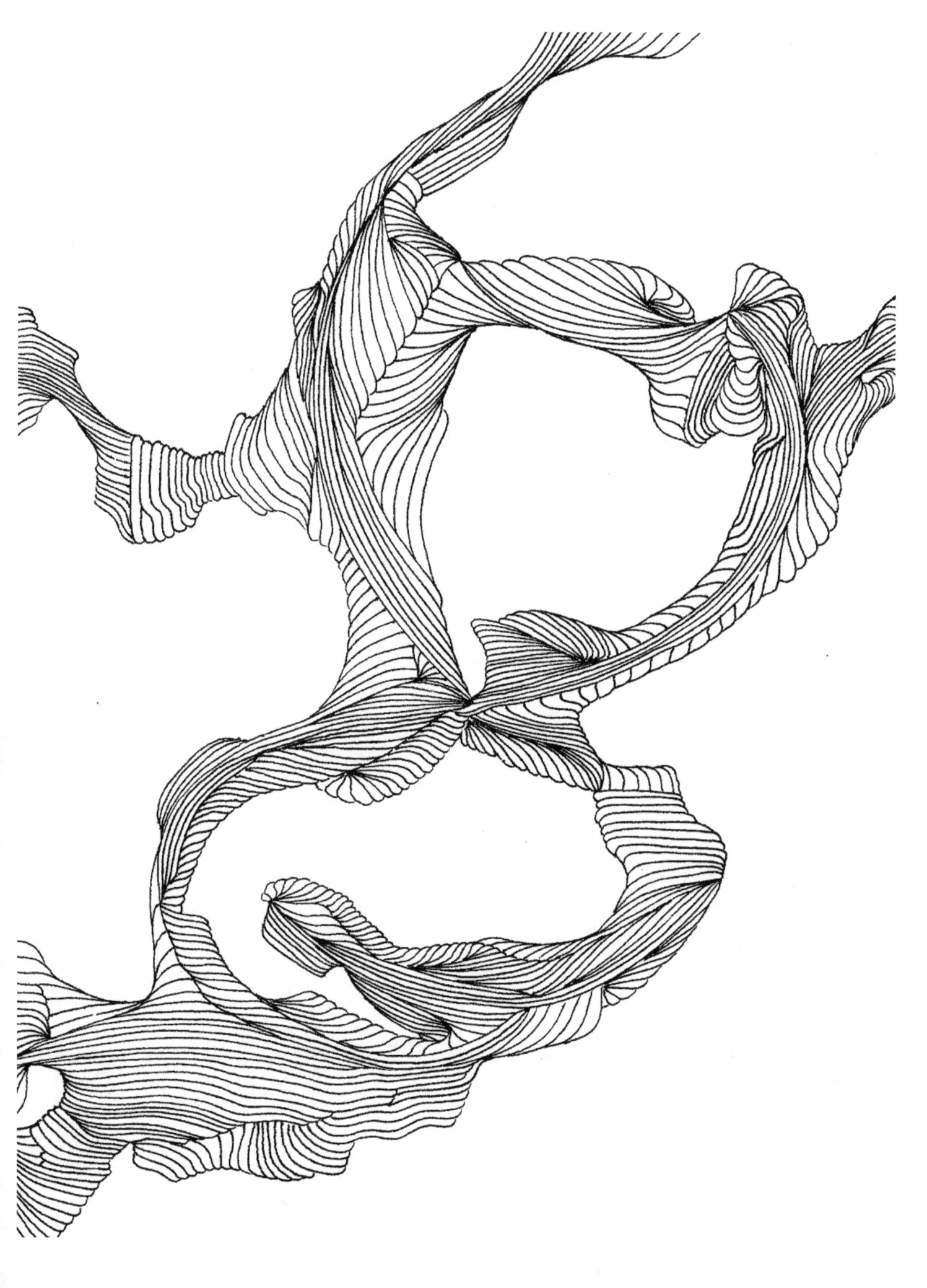

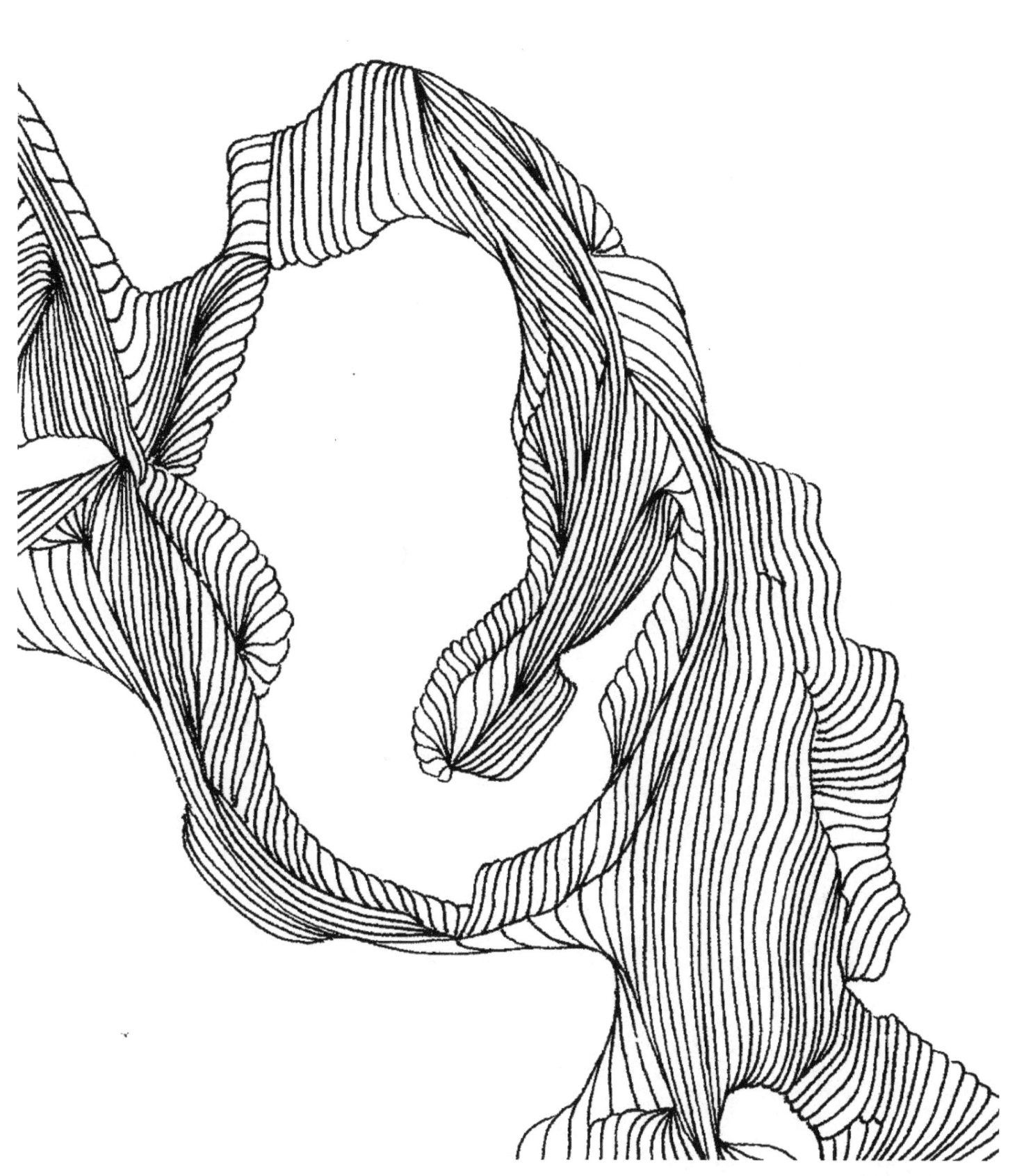

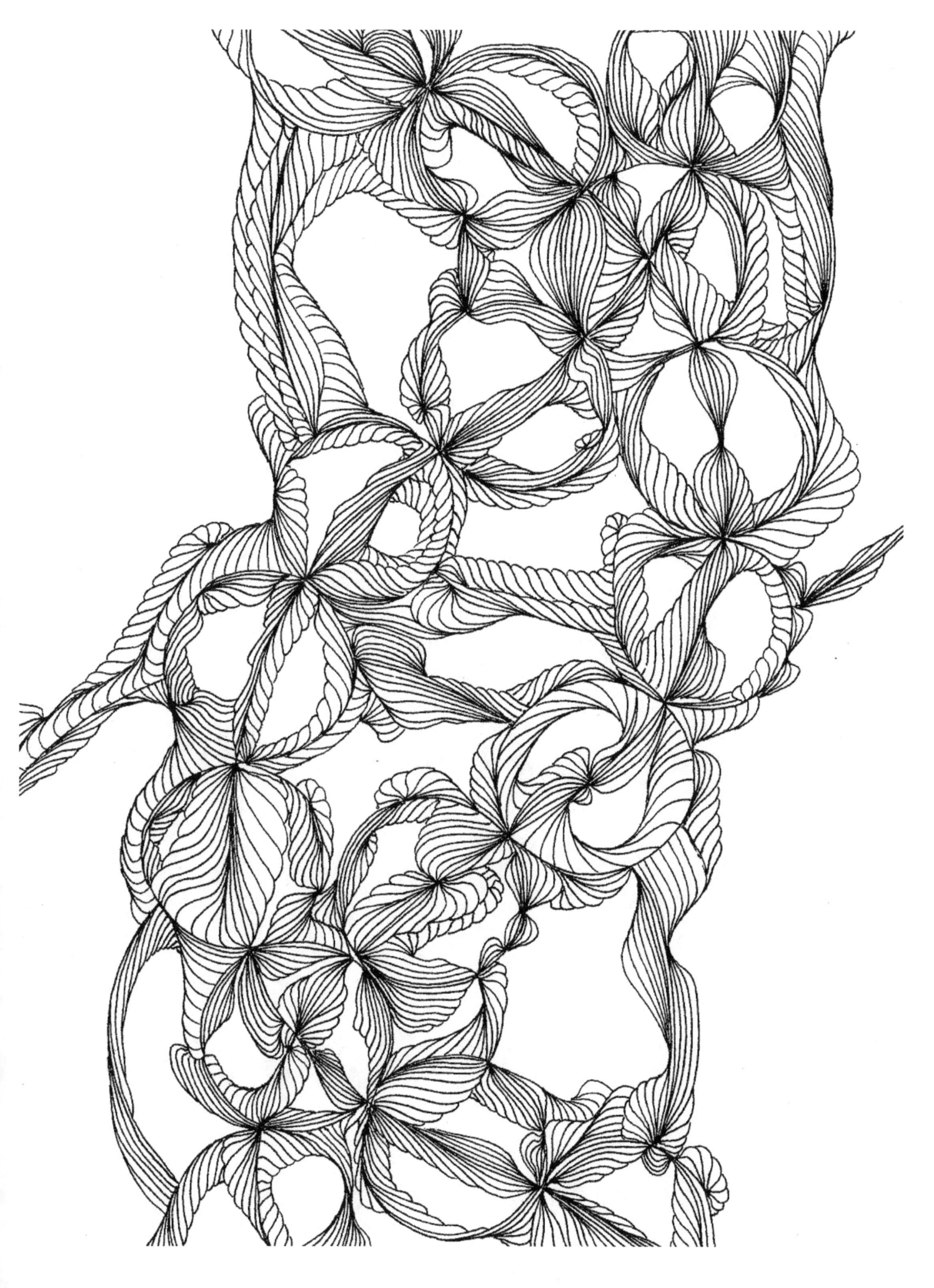

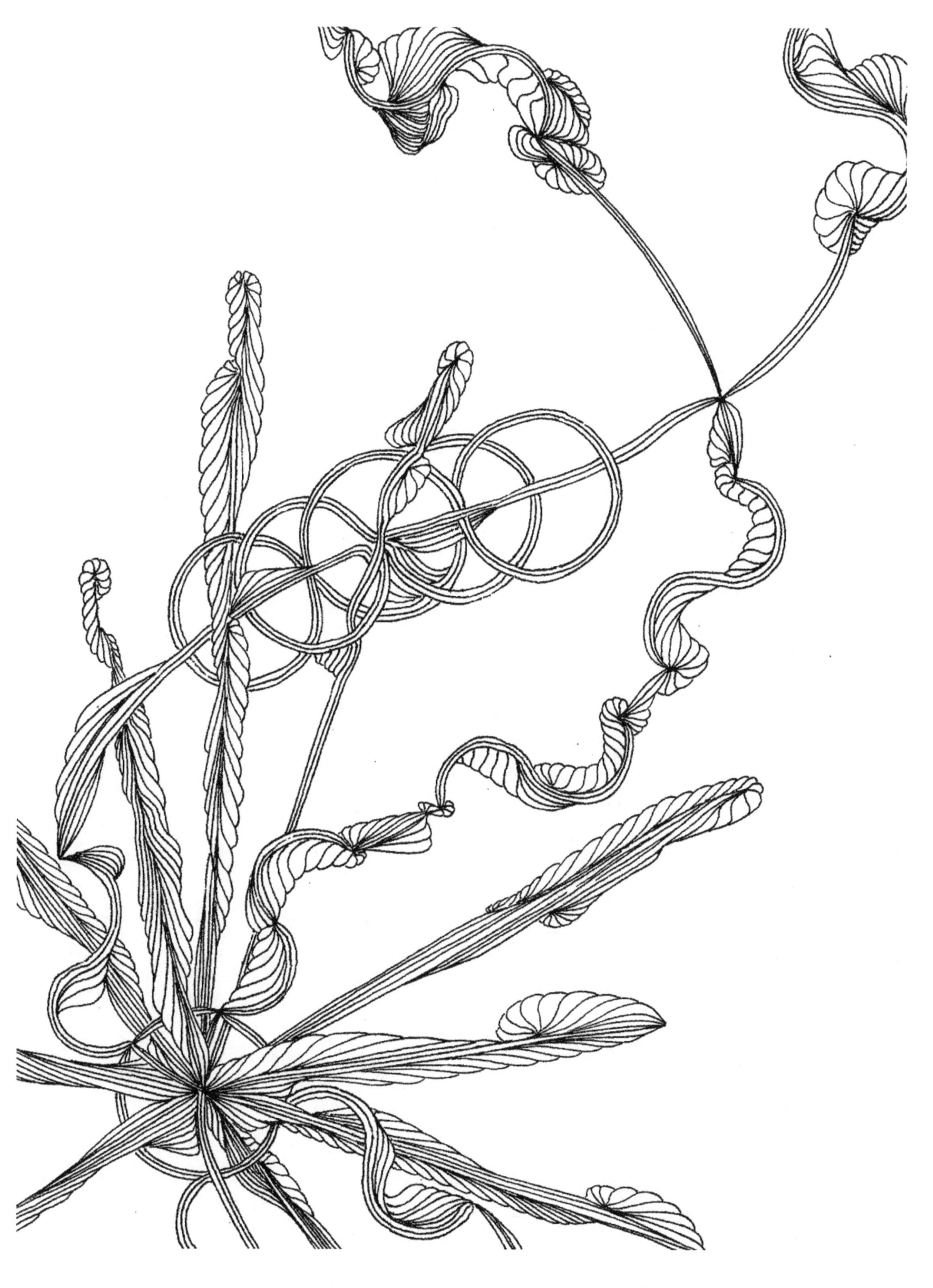

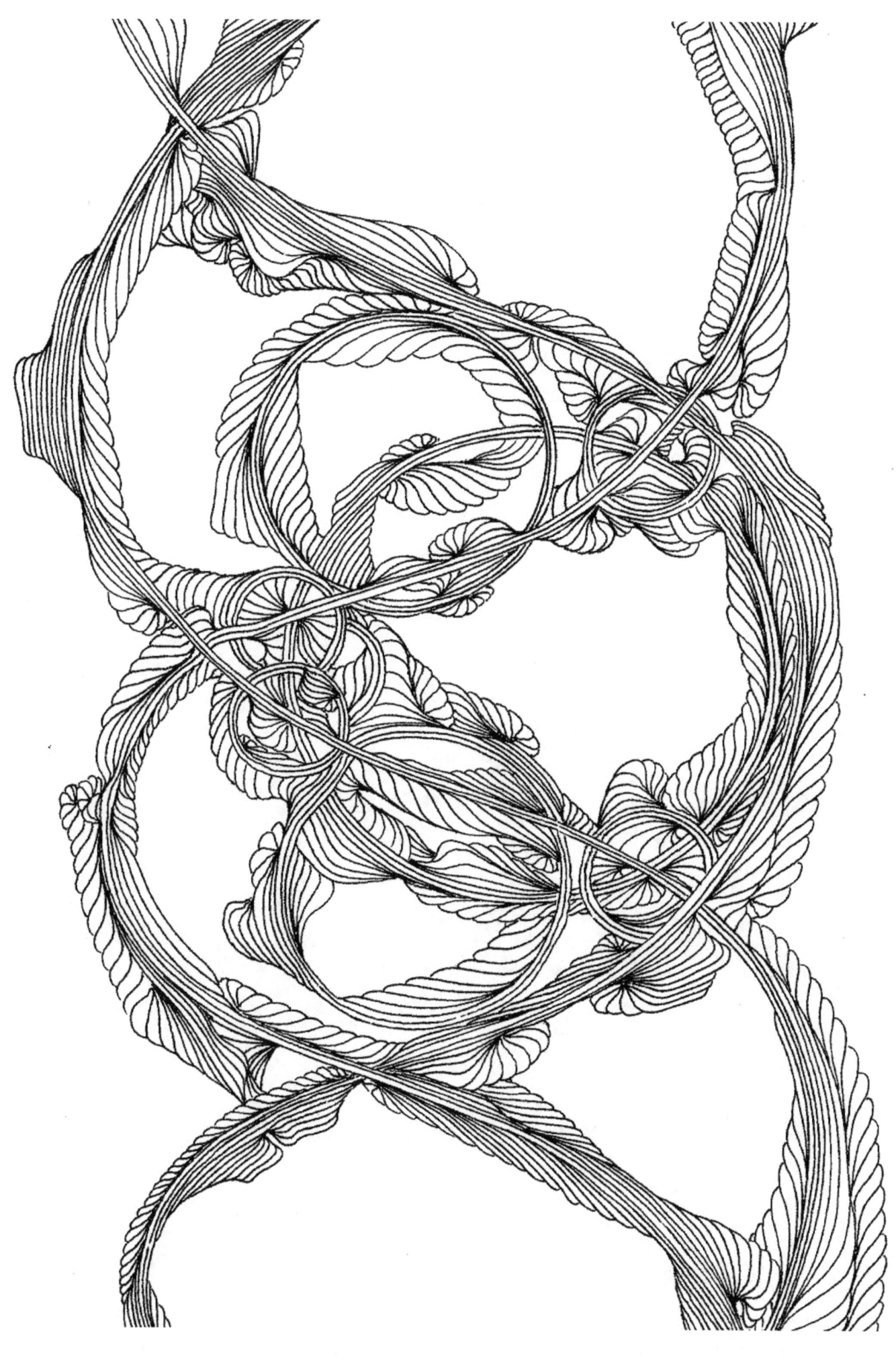

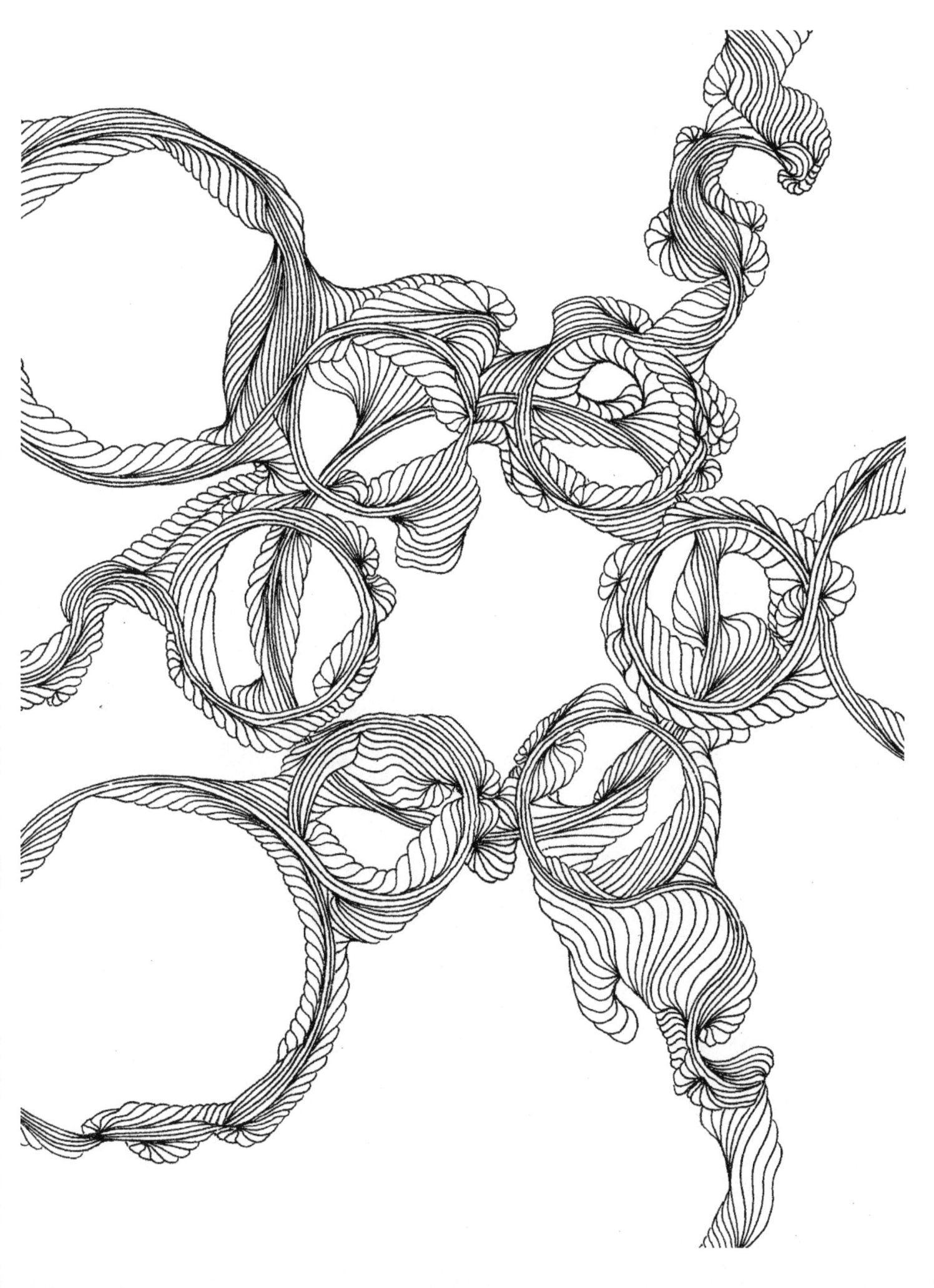

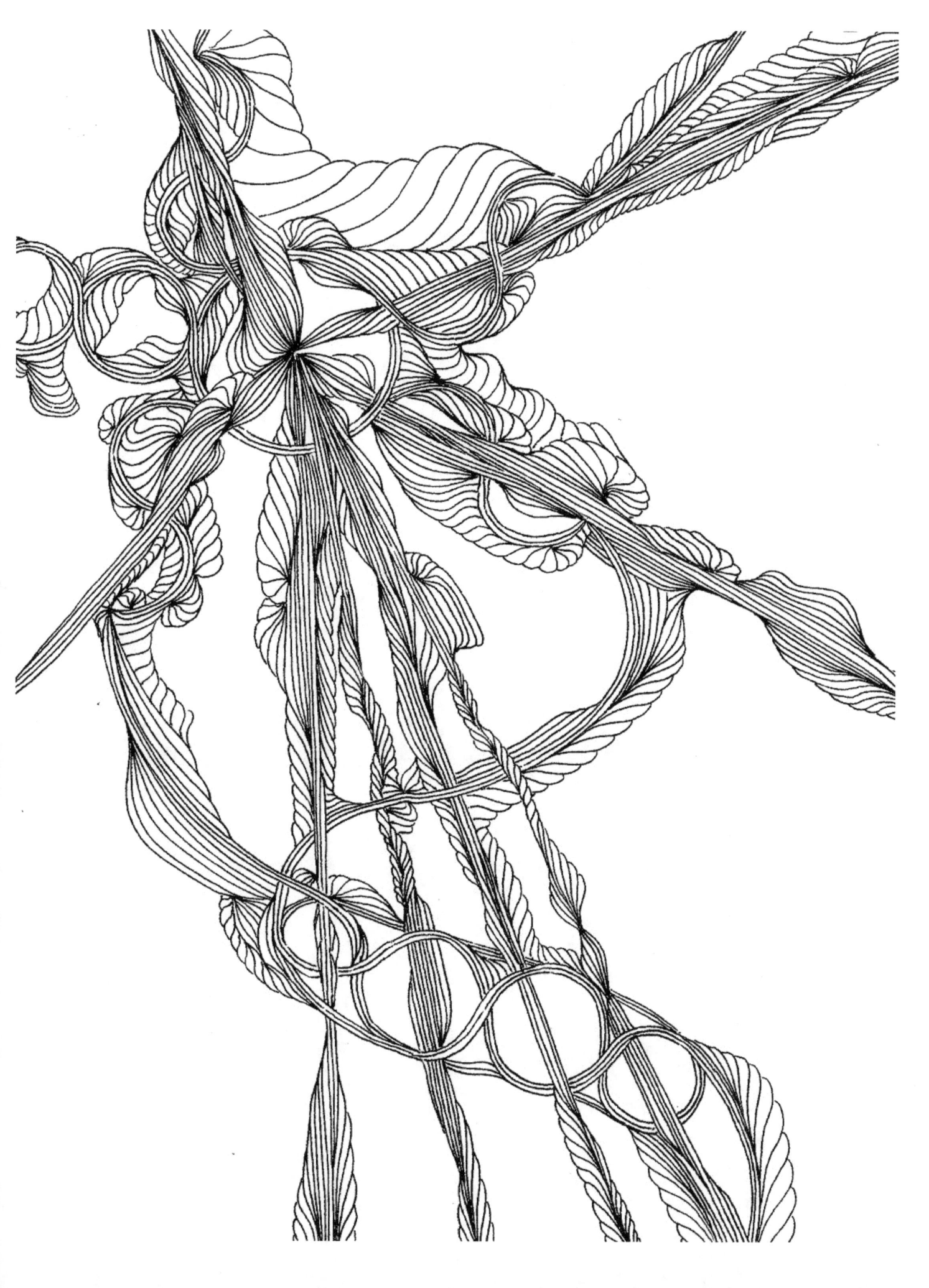

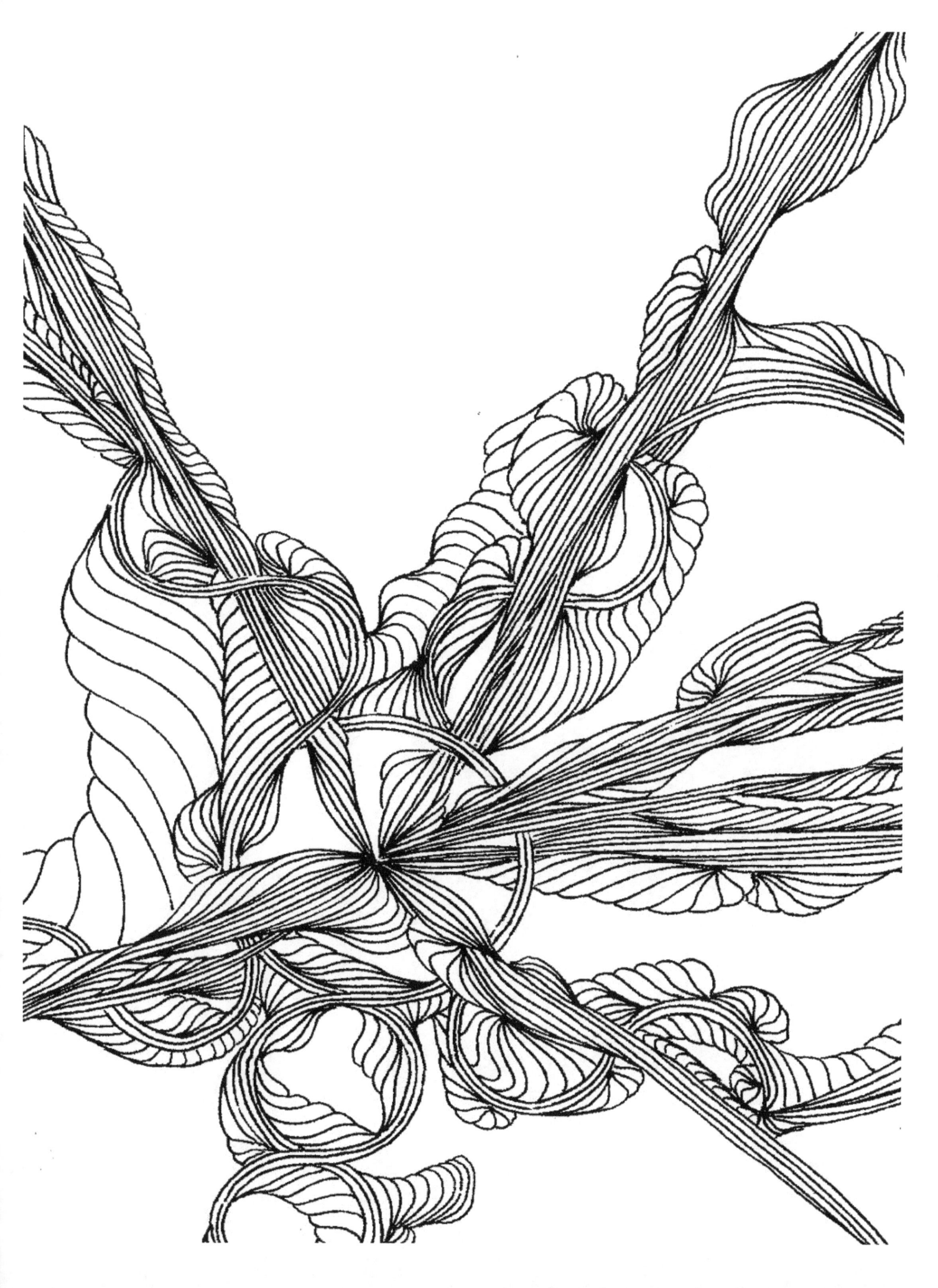

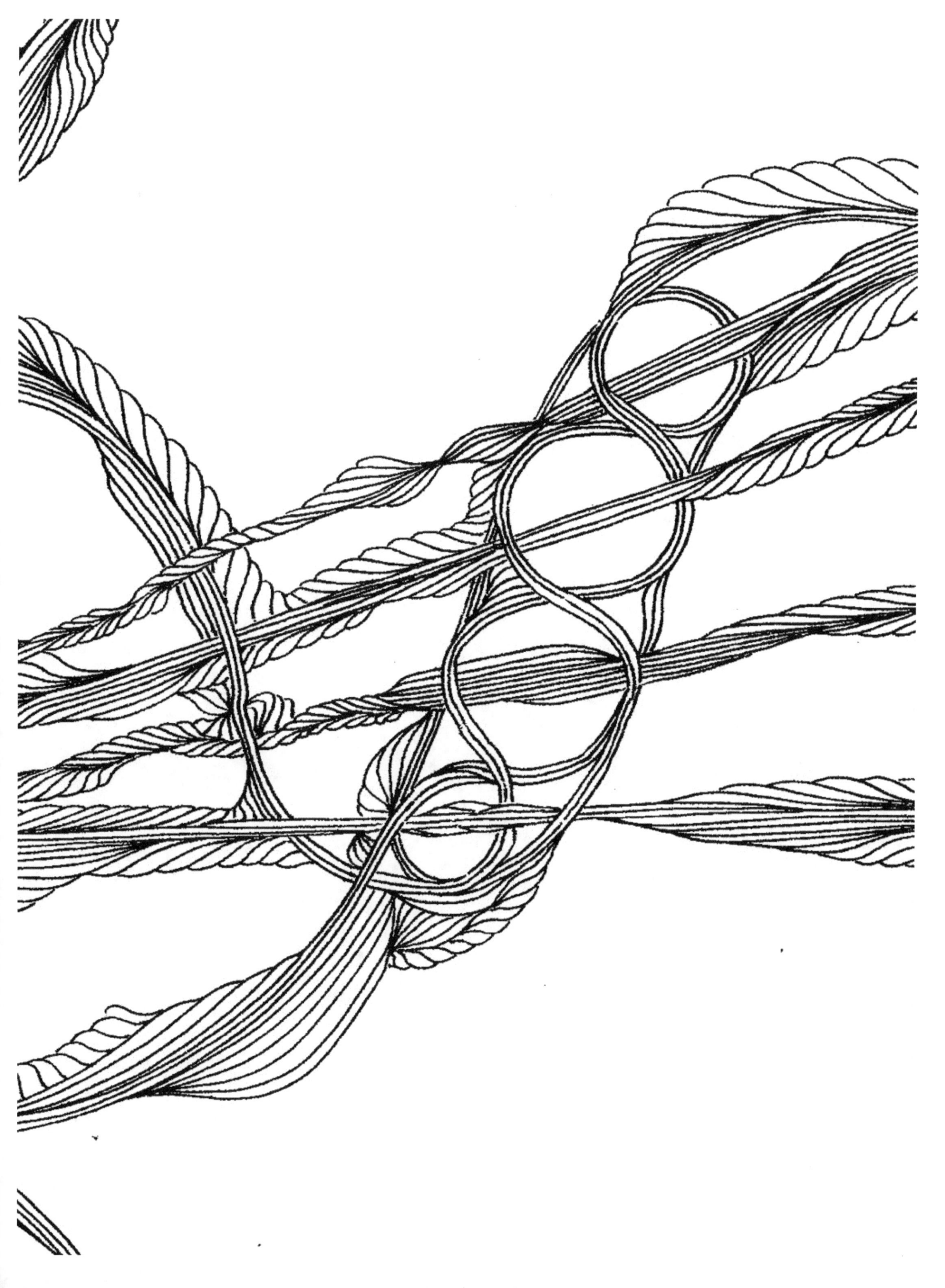

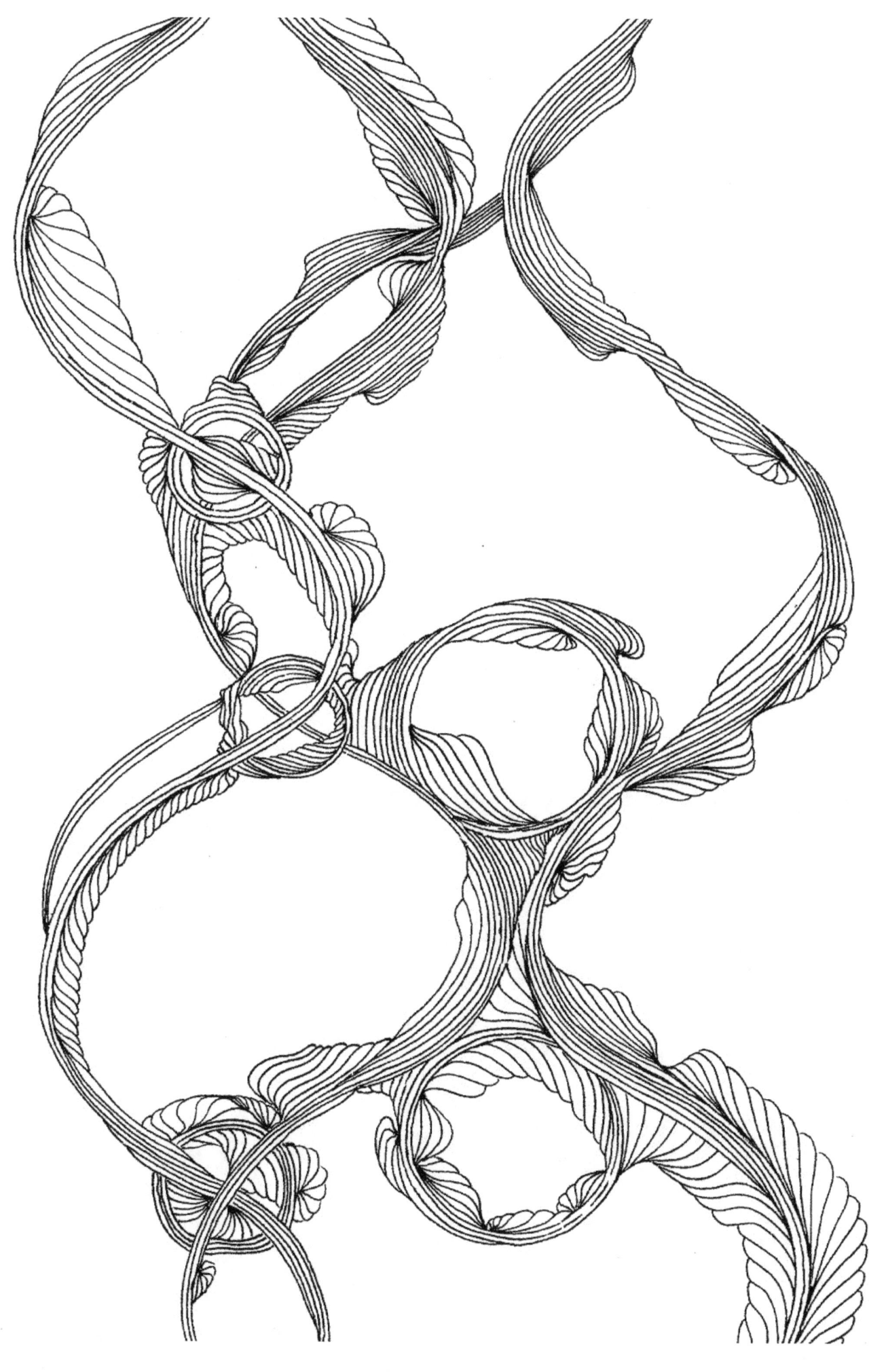

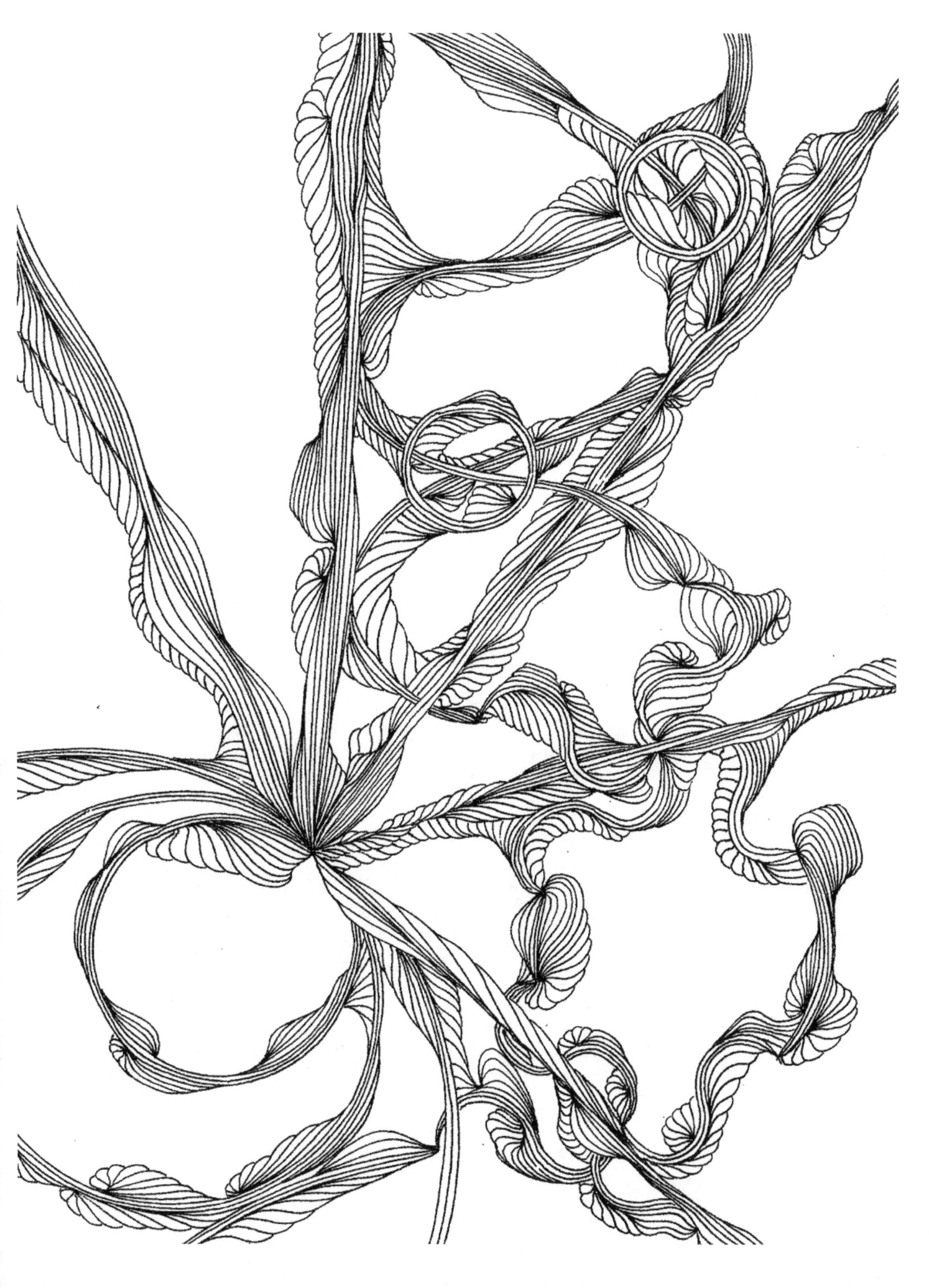

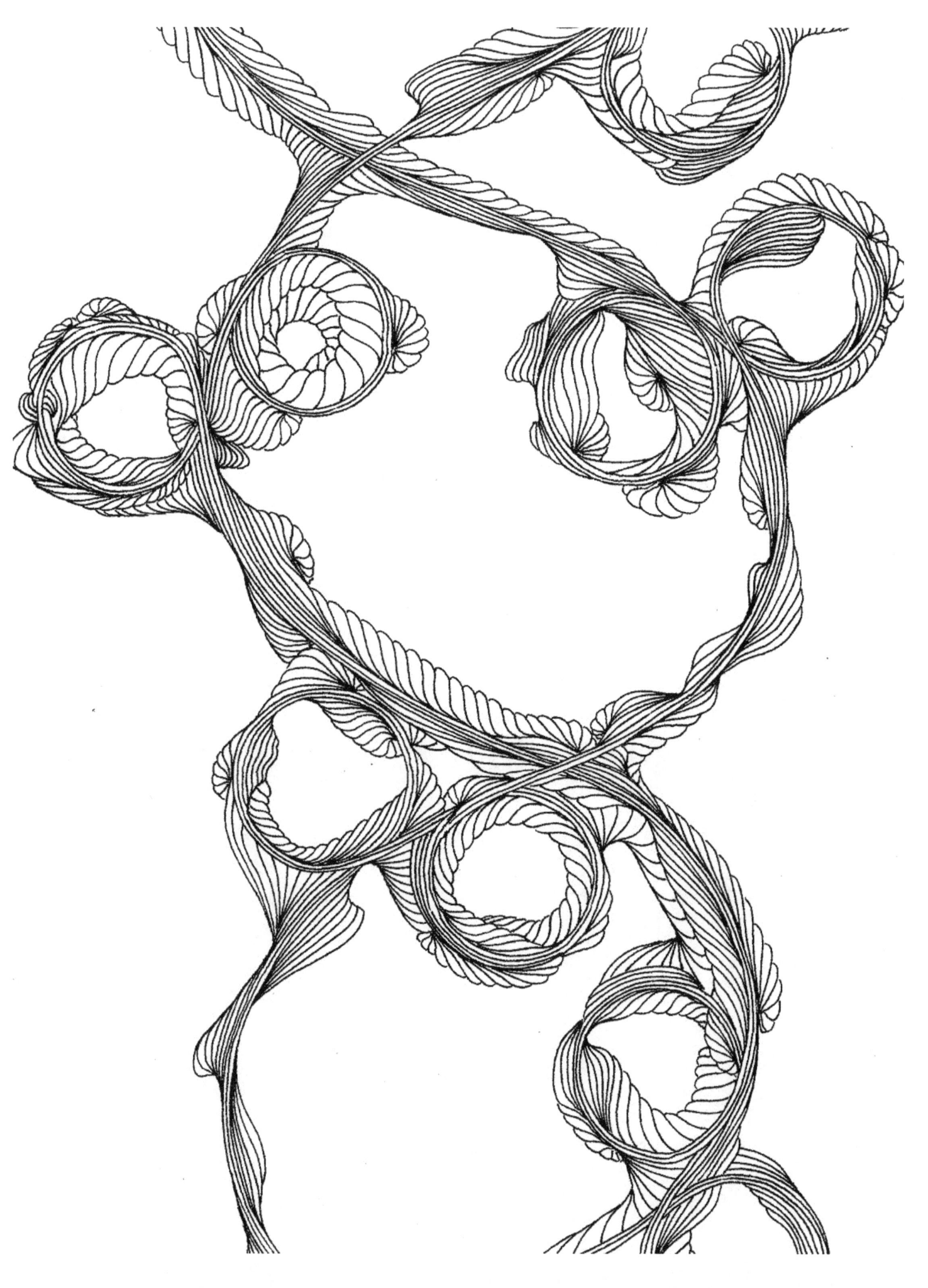

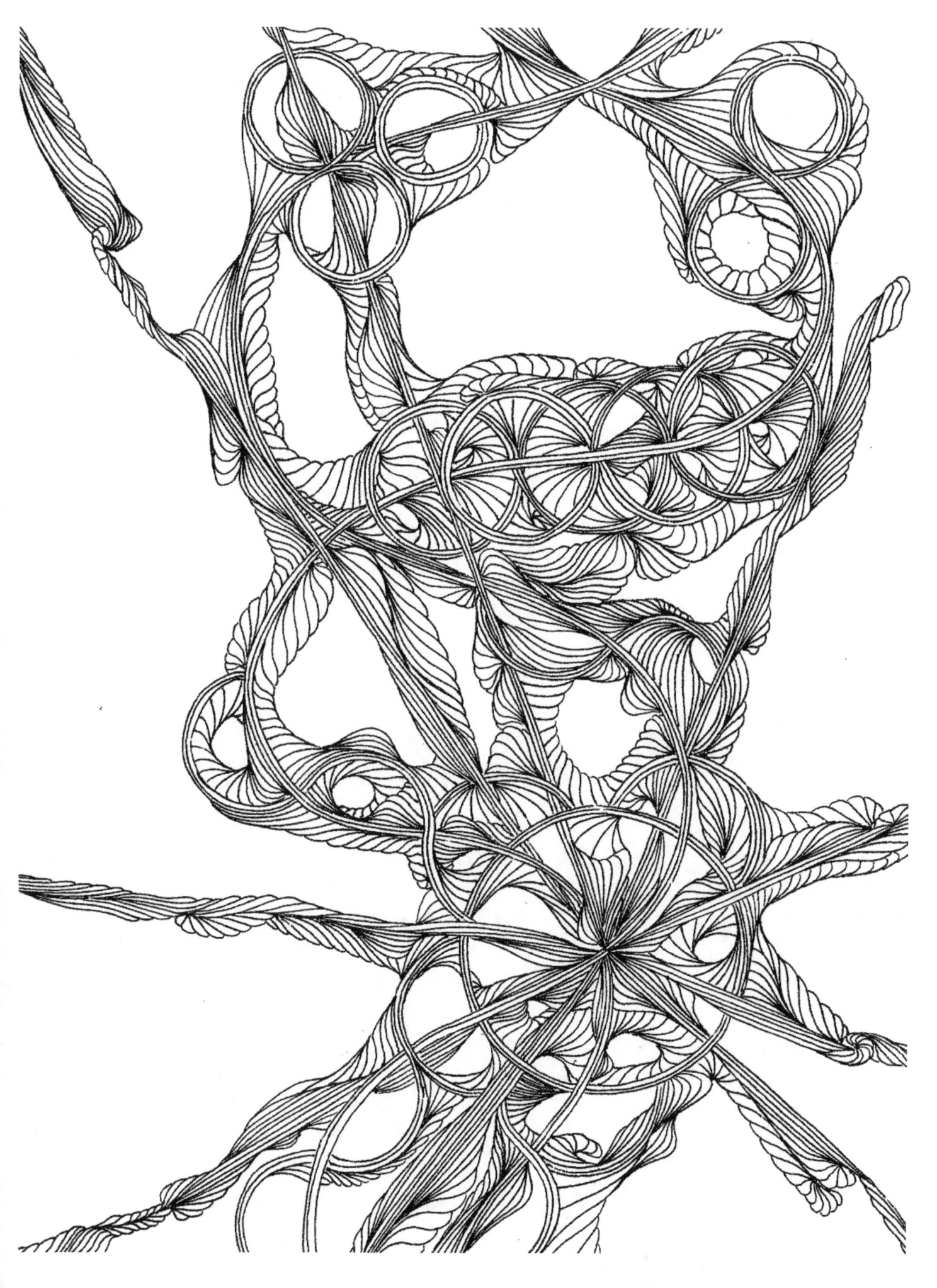

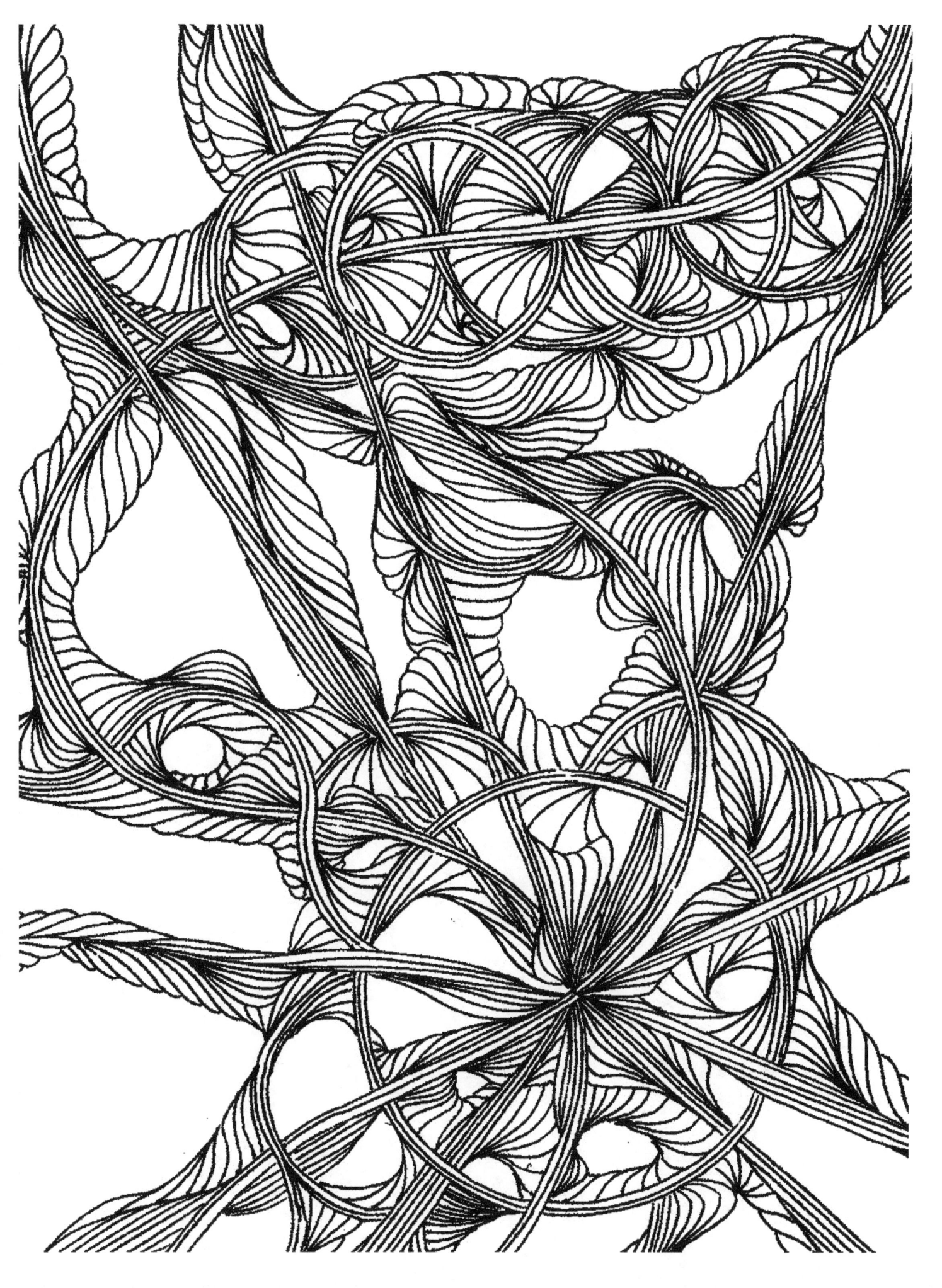

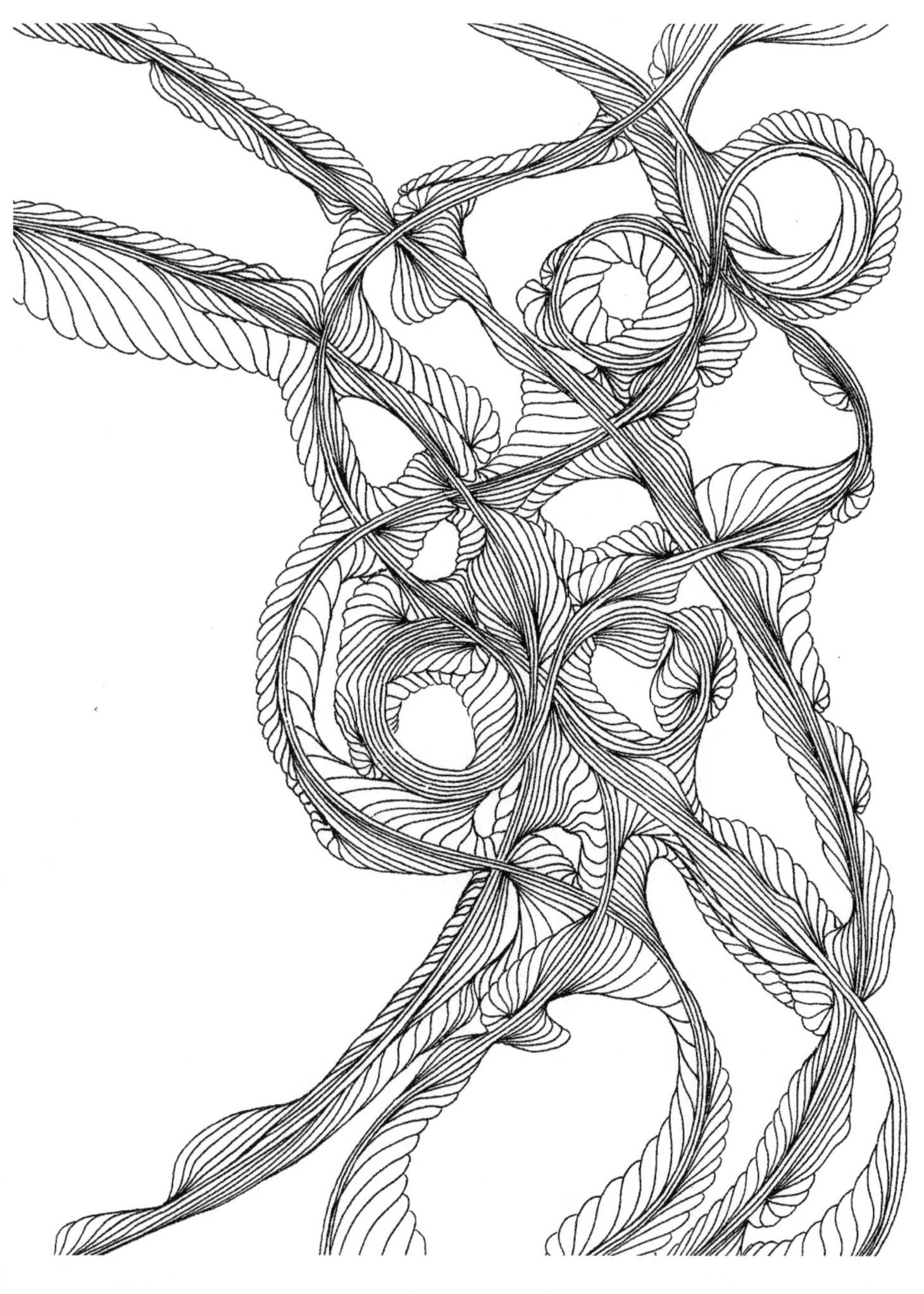

www.ingramcontent.com/pod-product-compliance
Lightning Source LLC
Chambersburg PA
CBHW080714190526
45169CB00006B/2372